IMAGES
of America

MOUNTAIN VIEW

Nicholas Perry

ARCADIA
PUBLISHING

Copyright © 2006 by Nicholas Perry
ISBN 978-0-7385-3136-6

Published by Arcadia Publishing
Charleston, South Carolina

Printed in the United States of America

Library of Congress Catalog Card Number: 2006921508

For all general information contact Arcadia Publishing at:
Telephone 843-853-2070
Fax 843-853-0044
E-mail sales@arcadiapublishing.com
For customer service and orders:
Toll-Free 1-888-313-2665

Visit us on the Internet at www.arcadiapublishing.com

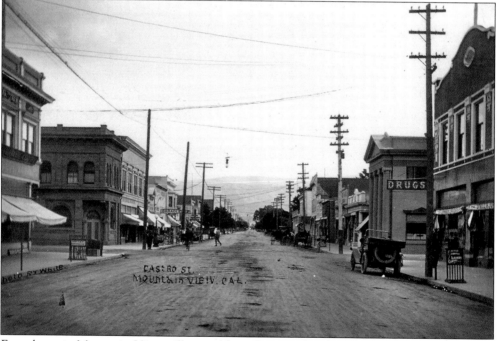

Few places in Mountain View still resemble a photograph taken nearly a century ago. This c. 1915 postcard of Castro Street at Villa Street is an exception. The four structures anchoring the corners of this prominent downtown intersection still stand as links to the city's past. (Courtesy Mountain View Historical Association.)

IMAGES
of America

MOUNTAIN VIEW

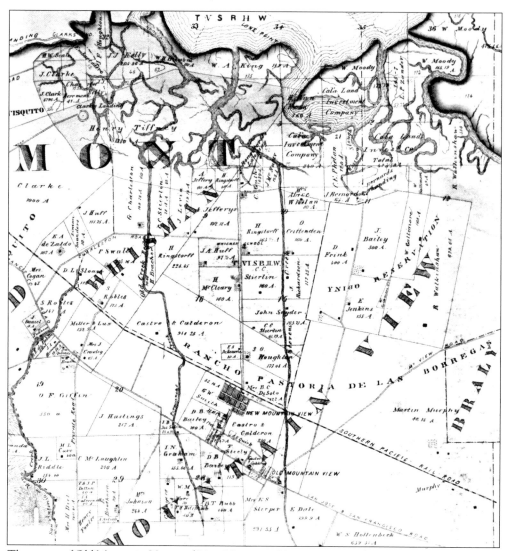

The towns of Old Mountain View and New Mountain View are pictured as two distinct settlements in this 1876 map of the Mountain View region. The arrival of the train in 1864 spurred the growth of New Mountain View, which today is the city's downtown district. Look closely at the map and you'll see the familiar names of early landowners who now have major streets named after them, such as Castro, Rengstorff, and Calderon. (Illustration from the *1876 Historical Atlas Map of Santa Clara County*, by Thompson and West.)

ON THE COVER: Mountain View's main thoroughfare, Castro Street, is pictured around 1950. (Courtesy Mountain View Public Library.)

CONTENTS

ACKNOWLEDGMENTS

There are so many people who have helped make this book a reality. First of all, I would like to thank my editor Hannah Clayborn and Arcadia Publishing for this wonderful opportunity. I also owe a huge thanks to Mountain View City historian Barbara McPheeters Kinchen. Her friendship, research, support, and amazing knowledge of Mountain View's history has been invaluable during every step of this book's creation.

Without the excellent image collections of the Mountain View Historical Association (MVHA) and Mountain View Public Library (MVPL) this book would not have been possible, and special thanks go to both of those organizations and the many photographers who have added to both collections over the decades. In addition, the following groups and individuals contributed their photographs, knowledge, and advice: Robert Weaver, Trudi Tuban, Madeline Borges of the SFV Society, IFES Society, Terry Kline, Bob Lee, and Reverend Dean Koyama of the Mountain View Buddhist Temple.

This book was quite a project, and the constant encouragement of all my friends has meant the world to me. A special thanks to Matt Chan for allowing me to borrow his scanner to digitize all the book's photographs, to Kat Webster for editing the introduction, and to Preeti Piplani for her unwavering support and assistance.

Finally I would like to thank my family. Like Mountain View, you guys are an inspirational tossed salad of cultures and personalities, and I love you all dearly. To my grandparents Elizabeth Perry and Simon and Emma Sias, I thank you for inspiring and encouraging my quest to learn more about our history. To my brother Chris, who shares my passion for Mountain View, thanks for being the best friend a guy could ever ask for—go Ags! Finally I owe the biggest thanks to my parents Mark and Gloria Perry. It would take another page to give them the proper acknowledgment for everything they've done to help make this dream come true. This book is dedicated to them.

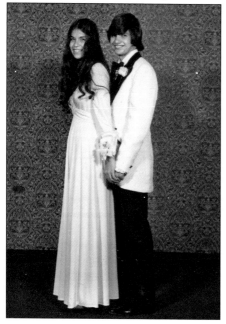

The author's parents, Gloria and Mark Perry, both grew up in Mountain View and graduated from the old Mountain View High School on Castro Street. The couple poses here for their portrait at the 1975 Mountain View High School prom.

INTRODUCTION

Constant change and deep-rooted diversity are the two phrases that come to mind when people think about the history of Mountain View, California. Ever since Spanish explorers and missionaries first forced the native Ohlone to leave their villages for Mission Santa Clara, the area that now encompasses Mountain View has gone through a series of stunning transformations, all the while attracting an increasingly diverse collection of settlers who have seen a great deal of potential in this little piece of the Bay Area.

Most of Mountain View falls within the former boundaries of *Rancho Pastoría de las Borregas* (ranch of the ewe lambs' pasture), an 8,800-acre land grant first given to Francisco Estrada by the newly formed Mexican government in 1842. Shortly after he received this grant, Estrada passed away, and the rancho was transferred to his father-in-law, Mariano Castro. The rancho era was short-lived, however. In 1848, California was taken from Mexico by the United States and the gold rush brought an influx of new settlers who began to purchase and squat on land owned by the Castro family.

In 1852, a stagecoach stop was established within the Castro rancho on El Camino Real near Stevens Creek, and a small village quickly sprouted up around it, providing the increasing number of travelers a place to rest on their way between San José and San Francisco. The village's first postmaster, Jacob Shumway, is credited for giving Mountain View its name after being inspired by the clear view of both the Santa Cruz and Diablo Mountain ranges from his store.

Just when the small village had begun to establish itself, the center of growth shifted a half-mile north when railroad tracks were laid through the Castro rancho. Mariano Castro's son and heir, Crisanto, plotted the streets of a "New Mountain View" at the Mountain View train station in the 1860s. Growth stagnated in the original village, which came to be known as Old Mountain View, and Castro Street soon replaced El Camino Real as the town's main street. The two settlements were viewed as distinct communities well into the 20th century.

On November 7, 1902, the City of Mountain View officially incorporated with a population of 610 residents. In 1903, the *Pacific Press*, a Seventh-day Adventist publishing company, moved its headquarters from Oakland to Mountain View. The arrival of dozens of Seventh-day Adventist families fueled a growth spurt in the city that transformed the western edge of town. As Mountain View matured, its diverse population began to set it apart. The Chinese presence in the city can be traced back as far as the 1870s. Large numbers of Japanese, Filipino, Spanish, Eastern European, Italian, Portuguese, and Mexican families came to the city during the first decades of the 20th century to work in the agricultural industry.

By the 1930s, Mountain View was a small but bustling city with a uniquely cosmopolitan population. Despite the negative perception some outsiders held because of its diversity, for most Mountain View residents the blue-collar and culturally rich character of the town became a source of community pride. The 1930s also brought an increase in the city's economic diversity with the opening of Moffett Naval Air Station in 1933 and the NACA (now NASA) Ames Research Center in 1939. The construction and operation of the two new federal facilities provided hundreds of local residents with much needed jobs as the Great Depression wore on.

Although Moffett Field helped nudge the town away from its agricultural emphasis, throughout the 1940s Mountain View remained a pleasant farming town nestled in a sea of blossoming orchards. The city's image was closely tied to the Santa Clara Valley's pastoral identity as the Valley of Heart's Delight. It was not until the end of World War II that Mountain View truly began to move away from its agricultural heritage, as developers rushed to provide returning veterans with their own piece of the American dream. City leaders eagerly welcomed the construction of

new subdivisions, schools, and shopping centers on the fertile land once covered by fruit trees and farms.

The early success of the high-tech industry in Mountain View sustained the postwar growth boom. In 1956, William Shockley, a controversial but brilliant inventor, established the first silicon-device research and manufacturing laboratory in an old apricot storage barn on San Antonio Road. The barn thus shares the title with the Hewlett Packard garage in Palo Alto as the "birthplace" of the Silicon Valley. From that point forward, the city has been home to numerous headquarters of leading Silicon Valley corporations, making Mountain View a center for innovation and new technology.

In the 1960s and 1970s, large swaths of land in Mountain View were converted into apartment complexes. This helped maintain Mountain View as an affordable locale for people of all backgrounds and caused the city's population to swell from 6,563 in 1950 to 54,131 in 1970. In the late 1980s, high-tech campuses and Shoreline Park replaced the last large agricultural area north of Highway 101. Without undeveloped land to expand on, redevelopment became the main trend of the 1990s. Both the city and private developers transformed downtown and older industrial and commercial districts into pedestrian-friendly neighborhoods connected to mass transit. Change continues today as companies like Google fuel growth throughout the city.

Ever since its earliest settlers moved the town center from El Camino Real to Castro Street, Mountain View residents have been eager to embrace change—perhaps, at times, a little too eager. Many of the places pictured in this book exist today only as memories. Talk to longtime Mountain View residents about their city and they'll likely mention a litany of things they miss, such as the sight of the old Mountain View High School on Castro Street, the taste of a Parisian burger from Linda's Drive-In or the sweet scent of apricot orchards in the springtime. But with age comes wisdom, and while change continues to occur today, it is paired with a growing appreciation of Mountain View's heritage.

While the images in this book offer a glimpse of how much physical change Mountain View has experienced, the stories behind these photographs show how much this city has stayed the same. Despite decades of constant reinvention, Mountain View has remained a place where people from all walks of life have come together and worked toward making this little city a place they are proud to call home.

One

THE SAN ANTONIO
DISTRICT

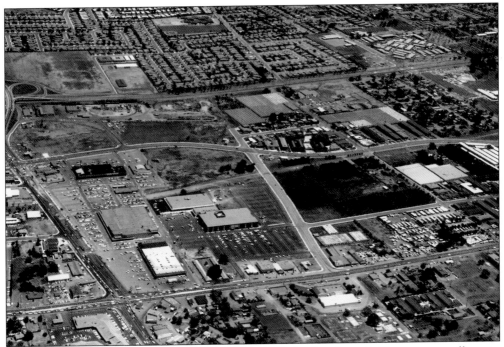

Portions of Mountain View's first major shopping mall, the San Antonio Center, were still empty fields when this 1961 aerial photograph of the San Antonio District was taken. The district's modern landscape of apartment complexes and shopping centers hides the important role it has played in Mountain View's history. From the city's first permanent dwelling to its first high-tech startup, the area has been home to many of the area's most important milestones. (Courtesy MVPL.)

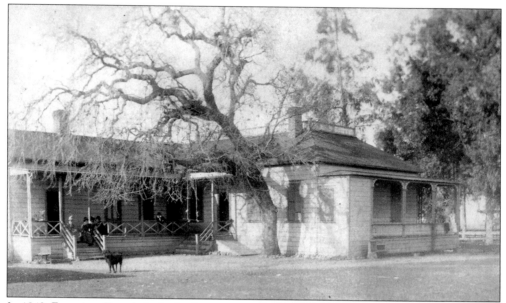

In 1842, Francisco Estrada built the first permanent residence in the vicinity of Mountain View near the intersection of what is now Central Expressway and Rengstorff Avenue. The modest adobe home was the heart of his vast Mexican-era land grant, *Rancho Pastoría de las Borregas*. After Estrada's untimely death in 1845, ownership was transferred to his father-in-law, Mariano Castro. The house pictured above was built by Castro sometime around 1850 to replace the old adobe. (Courtesy MVHA.)

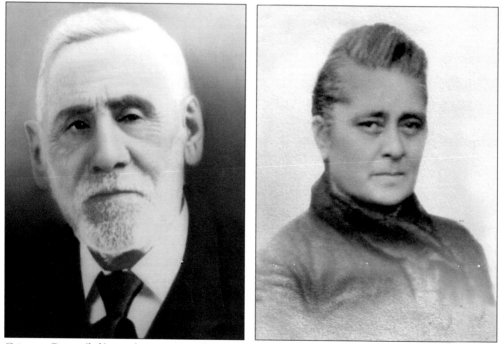

Crisanto Castro (left) was the youngest of Mariano and María Trinidad Peralta Castro's nine children. After the death of his parents, Crisanto took control of *Rancho Pastoria de las Borregas*, where he raised seven children with his wife, Francesca Armijo Castro (right). (Courtesy MVHA.)

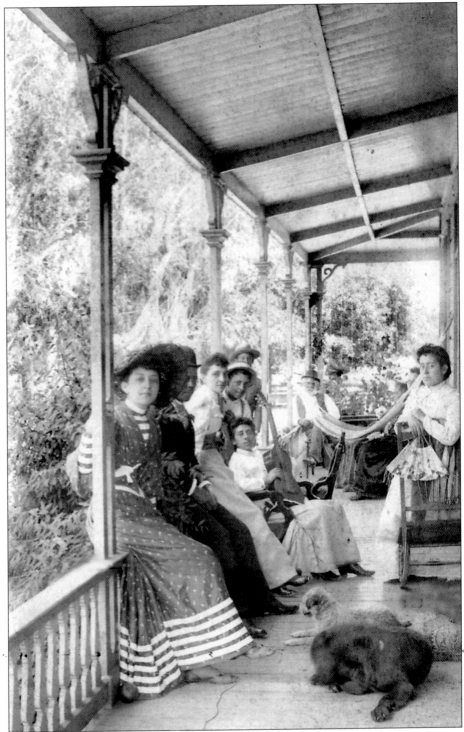

Various members of the Castro family are seen here relaxing on the porch of their home with their two dogs sometime near the turn of the century. The home was a hybrid of styles, mixing traditional adobe construction techniques with Victorian detailing. (Courtesy MVHA.)

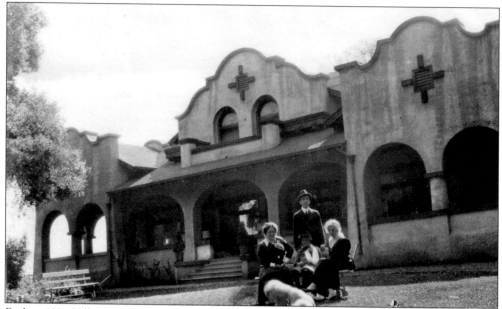

Built in 1911, Villa Francesca was the third and final residence of the Castro family. Crisanto Castro named the home after his wife, Francesca, who had passed away in 1907. In this photograph, four of their children are seen at the villa. Pictured, from left to right, they are Susan Castro, Crisanto IV Castro, Mercedes Castro, and in the back, Frank "Pancho" Castro. (Courtesy MVHA.)

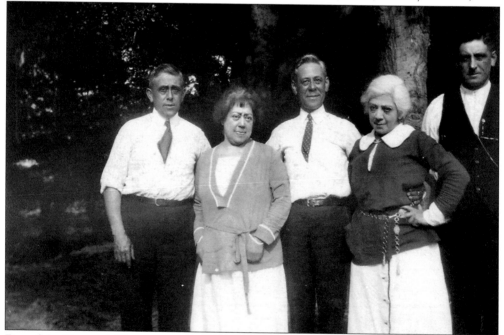

Five of the Castro children are pictured here as adults. Pictured, from left to right, they are Joe Castro, Susan Castro, Andrew Castro, Mercedes Castro, and Frank Castro. By the time this generation of Castros was born, most of their family's vast land holdings had been sold to pay off lawyer's fees during the long legal battle over land ownership that ensued once California became a state. (Courtesy MVHA.)

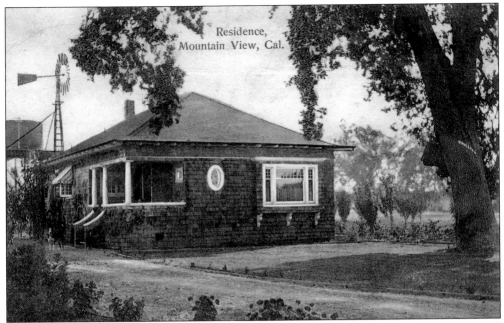

In 1908, a new subdivision named University Park was plotted just north of Villa Francesca and Southern Pacific's Castro Station. Land speculators gave it street names like Leland Avenue and Stanford Avenue and hoped that it would become a country retreat for Stanford professors and San Franciscans. Instead the neighborhood evolved into an affordable neighborhood for a Latino cannery and farm workers in the 1940s and was renamed Castro City by its residents. (Courtesy MVHA.)

Located at the corner of Rengstorff Avenue and Leland Avenue, the Castro City market was a longtime fixture of the Castro City neighborhood. From 1947 to 1992, it was owned by the Nakamura Family. Today the building is home to the Mi Pueblo Mercado. (Courtesy MVPL.)

Shirley Aristo (left) and Mary Blasquez (right) pose in front of Villa Francesca in this photograph taken during the 1950 Mountain View Harvest Festival. In 1958, Mercedes Castro sold the property to the city for the creation of a historical museum inside Villa Francesca and a park on the surrounding 23.5 acres. A suspicious fire partially damaged the villa in 1961, and the city—which had never been keen on renovating the structure—quickly demolished it. To add insult to injury, councilman Harry True successfully persuaded the city to name the park the Mountain View Recreation Center Park instead of Castro Park. He was quoted in the *Palo Alto Times* saying, "I go along that the Castro family was a great family in Mountain View, but this is 1959 and this park belongs to all the people of Mountain View. I would like to see the city's name on it." Ironically although the park has no connection to local pioneer Henry Rengstorff, it was renamed Rengstorff Park in 1970 because of its location on Rengstorff Avenue. (Courtesy MVHA.)

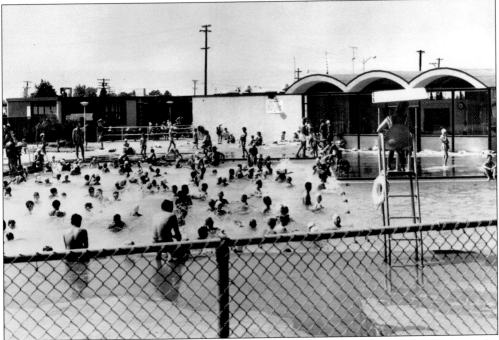

One of the first features to be completed at the Mountain View Recreation Center Park was the $206,000 city pool. Over 500 people packed the pool during its grand opening in 1959. Later phases of the park included a modern community center building that was completed in 1964. For many years, the city's Fourth of July celebration and fireworks show were held at the park. (Courtesy MVPL.)

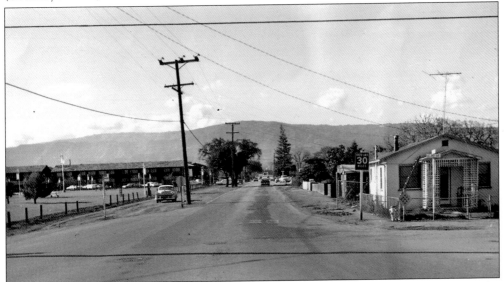

Rengstorff Avenue was originally known as Pastoria Avenue, in reference to its location near the heart of the Castro family's Rancho Pastoria de las Borregas. In 1929, the road was renamed to honor Henry Rengstorff, who once owned land along the road's northern stretch. This photograph shows the avenue in 1966, with Castro City at right and the newly landscaped Mountain View Recreation Center Park at left. (Courtesy MVPL.)

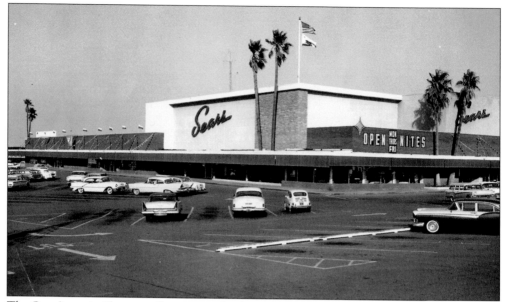

The San Antonio Shopping Center was the first major challenge to downtown's dominance as Mountain View's primary retail destination. The center began in 1957 with the construction of a Sears Department Store amidst bean fields on San Antonio Road. A year earlier, William Shockley established the area's first silicon-device research lab in an apricot barn just across the parking lot from Sears. (Courtesy MVPL.)

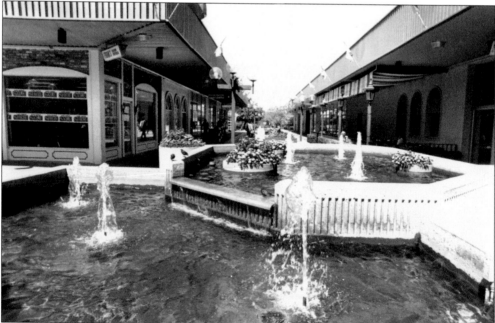

In the 1970s, the San Antonio Shopping Center underwent an extensive expansion that united its mishmash of freestanding stores with an outdoor pedestrian mall. One of the most memorable mall establishments was the Menu Tree, a large, two-story, cuckoo-clock-themed international restaurant located at the right side of this photograph. Most of the mall was demolished in 1995 to make way for a Wal-Mart. (Photograph by Dave Hitt; courtesy MVPL.)

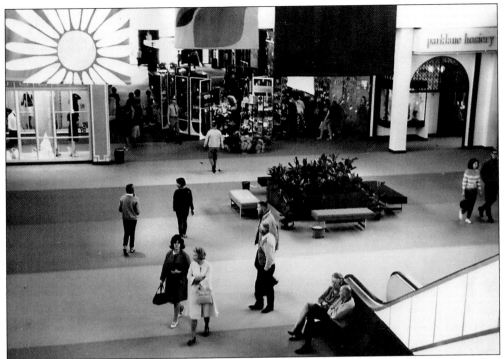

People from throughout the Bay Area flocked to Mayfield Mall when it opened in 1966 on San Antonio Road. Anchored by J. C. Penney, Mayfield was Northern California's first indoor, air-conditioned, and carpeted mall. The mall was located right on the border of Mountain View and Palo Alto and took its name from the now nonexistent town once located between the two cities. (Courtesy MVPL.)

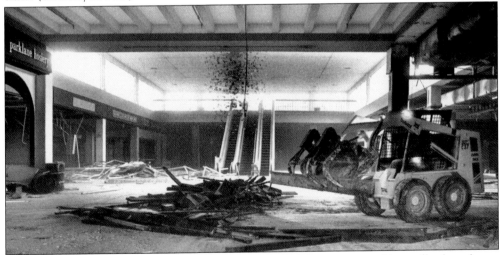

In today's era of big-box shopping centers, it is not uncommon to see older malls close due to competition. But when Mayfield Mall shut its doors in 1983, Mountain View residents reacted with surprise and sadness. Headlines proclaimed, "Even a mall may not be permanent," and "Closing 'our mall' will leave us feeling somewhat empty." In 1986, the mall was converted into Hewlett Packard offices and will soon be replaced with housing. (Photograph by Joe Melena; courtesy MVPL.)

In 1948, a new elementary school opened on Escuela Avenue (until the early 1940s it was Castro Avenue). The school was named Escuela Avenue School until 1957, when local residents decided it was ridiculous to have a school named School Avenue School. Since then, it has been named Mariano Castro Elementary School, in honor of Mountain View's founding father. (Courtesy MVPL.)

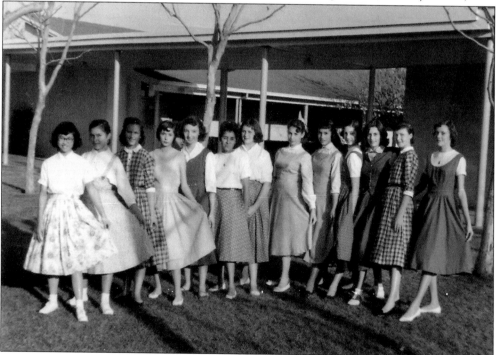

The 1956–1957 Escuela Avenue School sewing class poses in front of the school. Pictured, from left to right, are Linda Chan, unidentified, Sherry Garcia, Mabel Delucchi, Jeanine Paquier, Carlyn Ortez, Gloria Bernardi, Vera Melendy, Cecelia Stallmack, Myra Pickens, Diane L., and Patrice Lane. (Courtesy MVPL.)

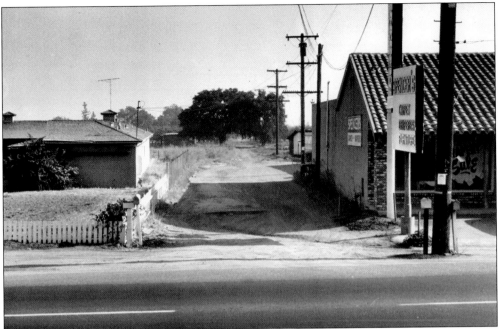

Showers Drive was once known as Showers Lane, a quiet country road shaded by oak tree groves. The lane was named after James Showers, an early Mountain View settler who owned farmland in the vicinity and served as a school trustee. This 1960 photograph shows Showers Lane from El Camino Real, right before it was widened. (Courtesy MVPL.)

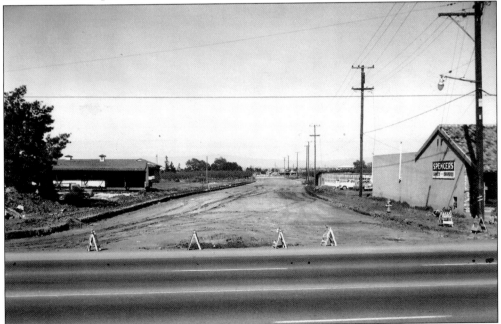

The newly widened Showers Drive nears completion in this photograph taken on September 7, 1961. The $500,000 project provided easy access to the San Antonio Center. Today the busy street is lined by stores such as Wal-Mart and Target, a far cry from the dirt lane it once was. The building at right still stands today. (Photograph by Deanne Fitzmaurice; courtesy MVPL.)

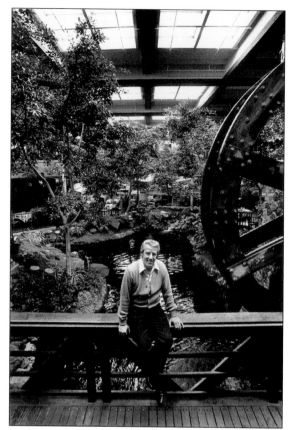

When it opened in 1975, the Old Mill Specialty Center instantly became Mountain View's biggest tourist draw. The indoor mall sported a unique award-winning interior design with shops and restaurants oriented around a two-story, tree-filled atrium that enclosed manmade ponds, creeks, and the center's namesake working wooden mill wheel. Co-owner Jack Reilly stands in front of the wooden mill wheel in this 1984 photograph. (Photograph by Sam Forencich; courtesy MVPL.)

The AMC Old Mill Six Theatres opened in 1975 as a part of the Old Mill specialty center. The theatres were one of the first suburban-style multiplex movie theatres in the Mountain View area. The Old Mill Six was the last tenant of the center to close prior to its demolition in 1994. (Courtesy MVPL.)

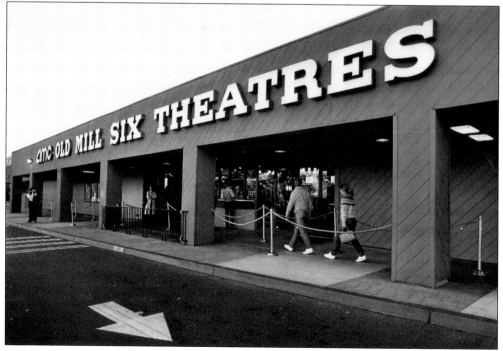

After the novelty factor wore off, the Old Mill had trouble attracting shoppers to its specialty stores. This 1988 photograph shows the atrium being gutted for a failed attempt to resurrect the center as a European-style public market. During the early 1990s, the Old Mill only opened its doors in October, when thousands of people would venture inside the abandoned mall to experience "Gyro's World of Terror." (Courtesy MVPL.)

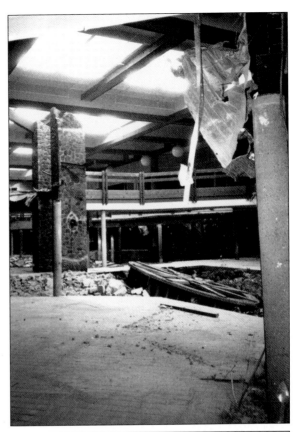

With the exception of Castro City, the San Antonio District is primarily home to a number of high-density apartment complexes. This c. 1960 photograph shows some of the first apartments being built along the newly widened and extended California Street. Originally envisioned as homes for young professionals, the apartments have since become affordable housing for many of the city's Latino immigrants. (Courtesy MVPL.)

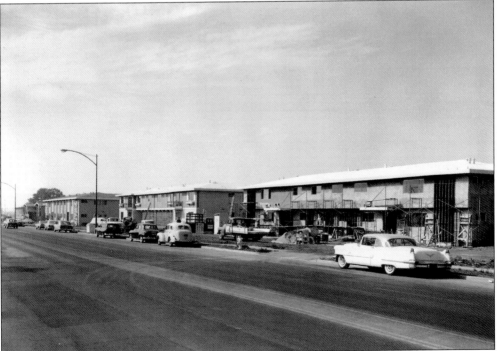

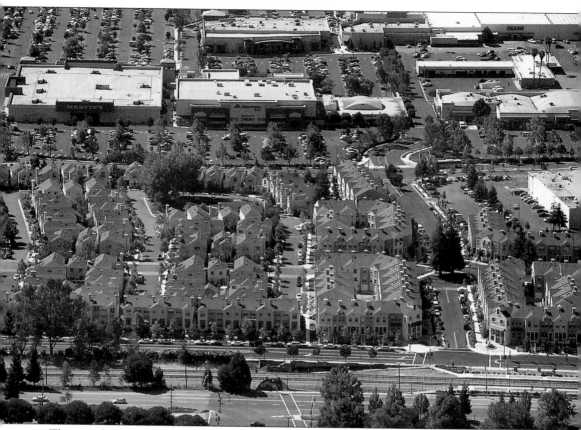

This aerial photograph shows The Crossings neighborhood and the northern portion of the San Antonio Shopping Center along California Street. Built and designed by Calthorpe Associates on the site of the Old Mill specialty center between 1994 and 1999, the neighborhood is one of the earliest "new urbanist" developments in California. Unlike typical subdivisions, The Crossings features a mix of housing types, stores, and open space all oriented toward the San Antonio Caltrain station. Pieces of the demolished Old Mill were actually used to create the foundations of The Crossing's homes. The opening of the San Antonio station prompted the closure of the Castro Station about a mile south of The Crossings, near Rengstorff Park and Castro City. For nearly 135 years, the station served local residents. Its first users were members of the Castro family, who had a special signal that could be used to wave down trains to stop near their home. (Photograph by Robert Weaver.)

Two

EL CAMINO REAL

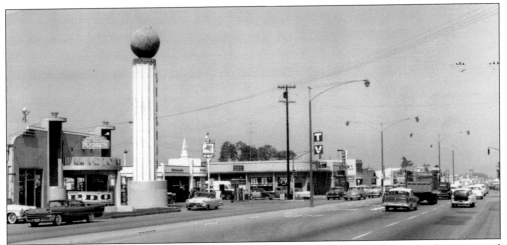

During the 1950s, El Camino Real returned to its role as Mountain View's principal commercial thoroughfare. The road has a long history stretching back to the era of stagecoaches in the 1850s. By the time this photograph was taken in 1957, the old highway had turned into a busy boulevard lined with popular drive-in restaurants, shopping centers, and mid-20th-century landmarks like the Mancini Motor's Globe Tower. (Courtesy MVPL.)

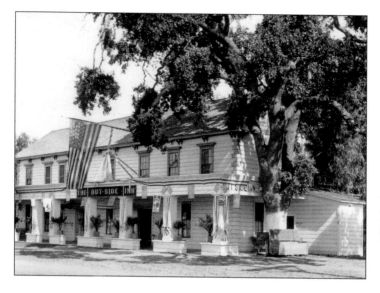

In 1863, Samuel P. Taylor built this hotel on El Camino Real. The building replaced Mountain View's first hotel that also served as the stagecoach stop and an early location for Catholic masses. Taylor's hotel went through a number of names—including the Mountain View House and the humorously titled Outside Inn—before it burned down in 1911. (Courtesy MVHA.)

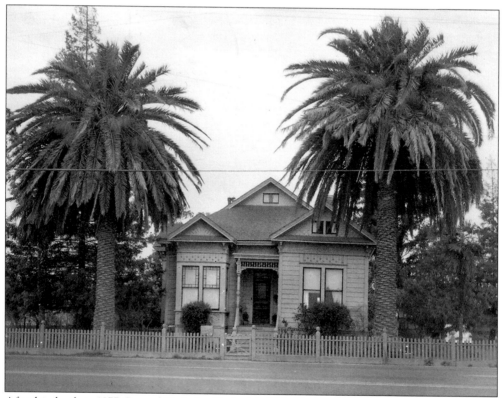

After his death in 1877, Samuel Taylor's wife, Letitia Kifer Taylor, moved into this Victorian home on El Camino Real. In addition to building his hotel, Samuel Taylor also served as the town's first Wells Fargo agent and second postmaster. Although the Taylor home was demolished in 1960, the palm trees in this photograph still stand in front of the Cusimano family's Colonial Mortuary on El Camino Real. (Courtesy MVHA.)

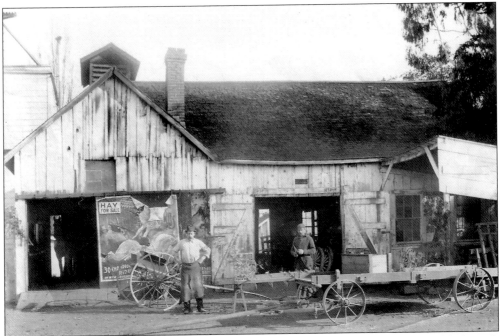

Daniel and Margaret Whelan came to Mountain View from Ireland and bought this blacksmith shop at El Camino Real near Grant Road in 1863. This photograph shows the blacksmith shop in 1909, a few years before the 1911 fire that destroyed the building. Tattered posters advertising the Ringling Brother's circus are posted on the shop's walls. The family operated the blacksmith shop until 1945. (Courtesy MVHA.)

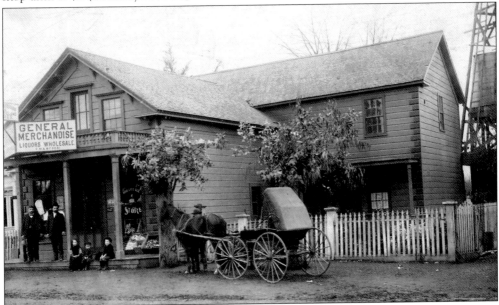

Brothers Andrew and Victor Manfredi came to Mountain View from Palermo, Italy, in the 1880s. Victor Manfredi was known as the mayor of Old Mountain View and operated the general store pictured here on El Camino Real during the late 1800s and early 1900s. Today an In-N-Out Burger restaurant stands on the site of the store. (Courtesy MVPL.)

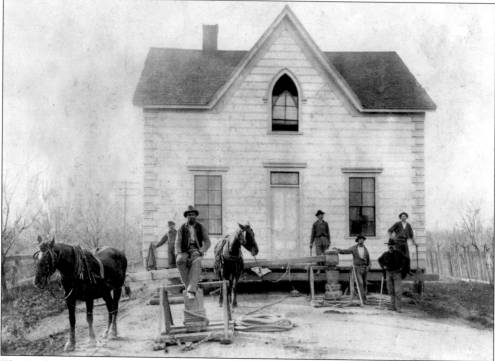

The Andrew Manfredi house has a history of being on the move. This 1903 photograph shows its relocation to New Mountain View on Dana Street, closer to Manfredi's Union Hotel on Castro Street. The house was originally built in 1875 on El Camino Real for Dr. Nathaniel Eaton. Eaton filled many roles in Mountain View's early history, including physician, pharmacist, school trustee, and justice of the peace. (Courtesy MVHA.)

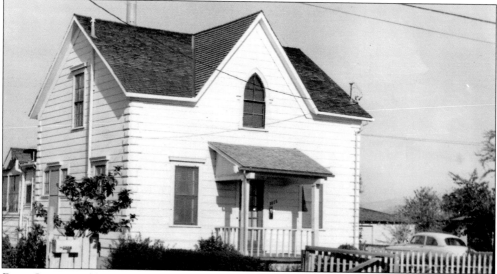

Dana Street would not be the last stop for the Andrew Manfredi house. The house's northward migration continued when it was relocated to this site on Wright Avenue. The second floor was removed sometime in the 1960s. Today the 130-plus-year-old home is the only surviving building from the town of Old Mountain View. (Courtesy MVHA.)

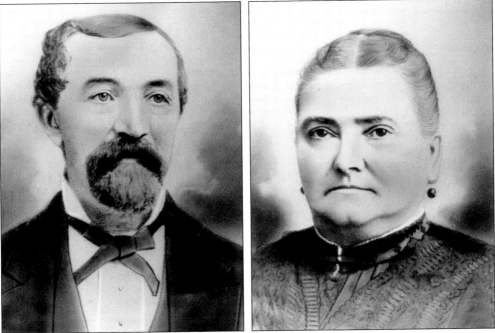

Seligman (left) and Sophie Weilheimer (right) were German Jewish immigrants who came to Mountain View in the 1850s and were prominent in the town's early history. The couple was married in 1856 in San Francisco and raised their five children in Mountain View. Seligman and his brother Samuel established a general store on El Camino Real in 1855. (Courtesy MVHA.)

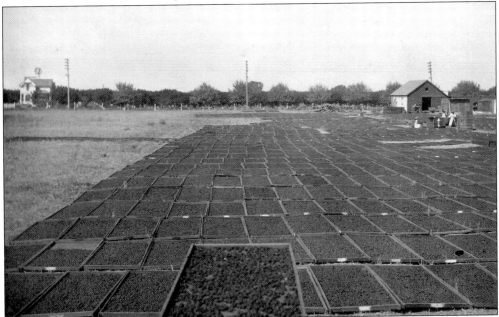

The Dale ranch was a prominent feature on Mountain View's stretch of El Camino Real from the 1850s to the 1970s. Edward Dale and his family arrived from Missouri via covered wagon in 1850. In 1854, he purchased 100 acres in the vicinity of today's Dale Avenue. Trays of drying apricots and the Dale family house are shown in this undated postcard of the ranch. (Courtesy MVHA.)

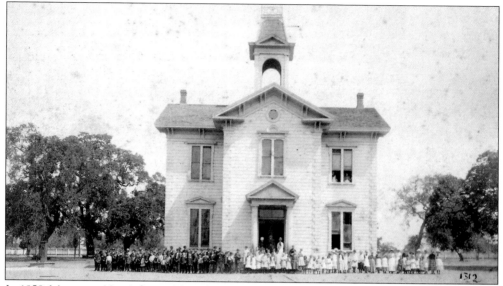

In 1858, Mountain View's first public school was built on El Camino Real near Calderon Avenue on land donated by Crisanto Castro. The school pictured above was built in 1875 to replace the original structure that burned down in 1872. The two-story structure housed six classrooms. (Courtesy MVHA.)

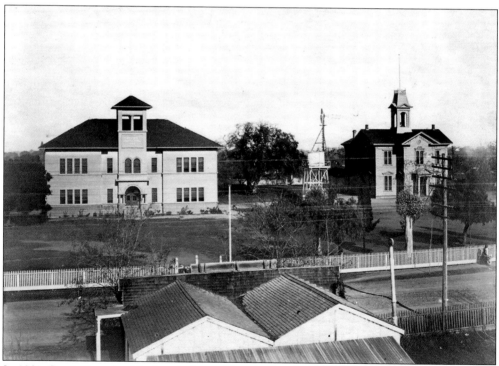

In 1901, Carrie Beverly visited a relative in Campbell and was upset to see that the smaller town had a high school while Mountain View did not. Beverly initiated the successful campaign to build the first Mountain View High School, at left, next to the grammar school in 1902. An unpaved El Camino Real runs through the center of this photograph. (Courtesy MVHA.)

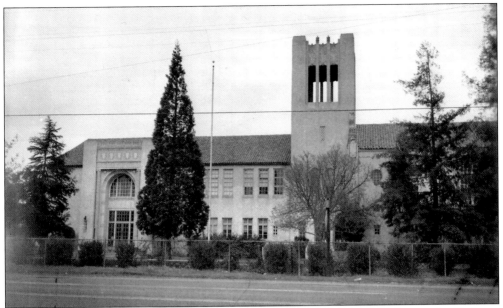

In 1928, the old high school and grammar school were demolished to make way for Highway Elementary School. The ornate two-story structure contained 22 classrooms. In 1955, Highway School closed and from 1958 until its demolition in 1962 the structure was home to Foothill Community College. Foothill continues to use the old Highway School's mascot, the Owl, at its Los Altos Hills campus. (Courtesy MVHA.)

The 1939 eighth-grade class of Highway School poses in front of its main entrance along with their teacher Grace Lawson (top row, second to right with the glasses) and principal Kenneth Slater (top row, in the coat, tie, and glasses). The students pose behind three framed scenes of the 1939 World's Fair, which was being held on Treasure Island in San Francisco. (Courtesy MVHA.)

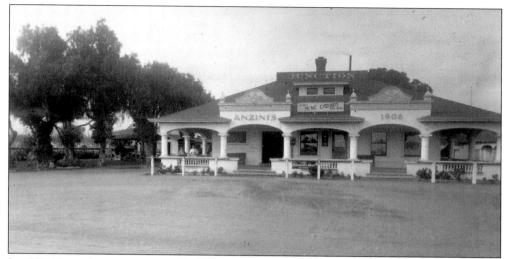

In 1901, Victor Anzini, a native of Switzerland, opened the Junction House at the intersection of El Camino Real near El Monte Avenue. The Junction House served as a country resort and picnic grounds and was a popular destination for tourists. In later years, it was known as the Cloverleaf Club, a notorious saloon and gambling house. On November 13, 1941, a fire completely destroyed the structure. (Courtesy MVHA.)

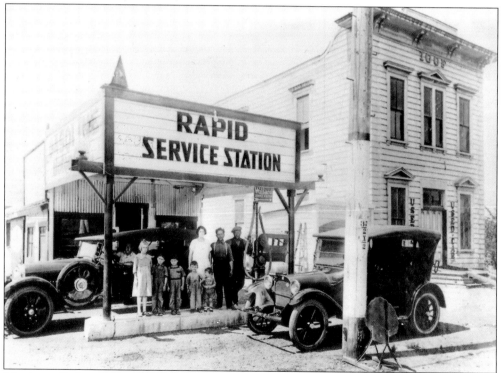

Members of Italian immigrant Ugo Mancini's family are pictured here in front of their Old Mountain View service station in the early 1920s. The two-story structure in the background was known as Enterprise Hall. Built in 1876, the second floor of the hall was the lodge of the International Order of Odd Fellows (IOOF). The hall was also used as an early court for Mountain View High School's basketball team. (Courtesy MVPL.)

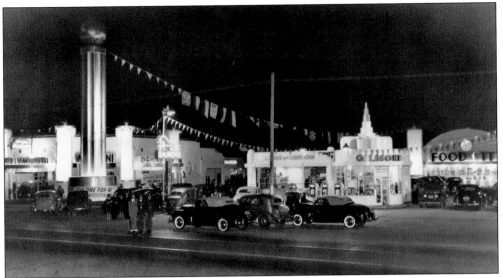

The beginning of El Camino Real's transformation from a country highway into a suburban boulevard could be traced to the grand-opening celebration of Mancini Motors, pictured here on September 20, 1940. The complex also included the Food City grocery and Gilmore gas station. The impressive complex of modern buildings included a landmark globe tower that owner Ugo Mancini brought from the Chrysler exhibit at the Treasure Island World's Fair. (Courtesy MVPL.)

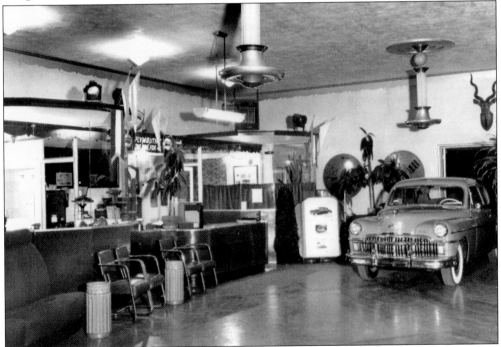

Pictured here is the ornate interior of Mancini's Plymouth/DeSoto dealership in 1940. The building featured 16,000 square feet of space and light standards from the Chrysler World's Fair exhibit that replicated the design of the globe tower standing outside. The entire complex was demolished in 1974 and replaced by a bank building currently standing on the southeast corner of El Camino Real and Castro Street. (Courtesy MVPL.)

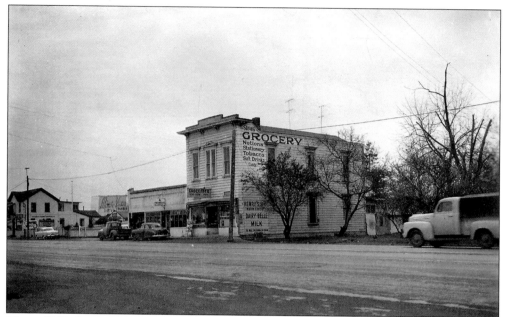

This *c.* 1950 photograph shows El Camino Real at Bay Street shortly before the last traces of Old Mountain View were wiped away. The Beverley Home, an Old Town landmark at the far left, was demolished in 1962. Enterprise Hall (center) was the oldest business building in Old Town when it was leveled sometime in the mid-1960s. In the distance rises the screen of the Monte Vista Drive-In Theatre, a sign of things to come. (Courtesy MVHA.)

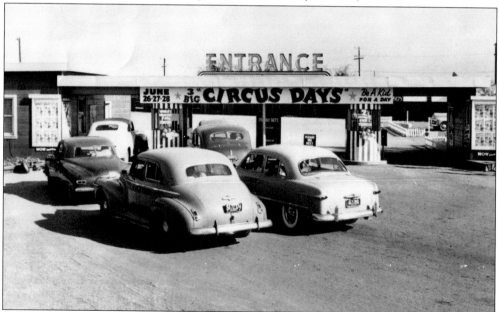

Cars queue up to enter the Monte Vista Drive-In Theatre located on Grant Road near El Camino Real. The drive-in opened on August 4, 1950, on land once occupied by a prune orchard. The $150,000 one-screen facility could hold 825 cars. On opening night, admission was only 65¢ for adults and 40¢ for juniors. The drive-in closed in 1978 and was replaced by the Monte Vista low-income apartment complex and the Bentley Square subdivision. (Courtesy MVPL.)

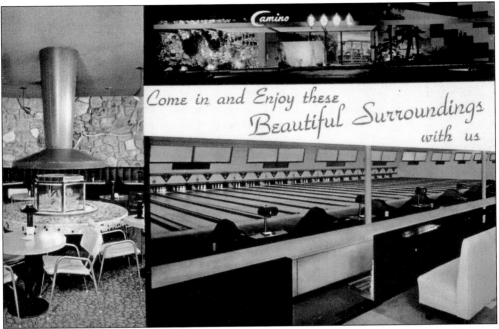

In 1956, John Gemello, owner of Mountain View's last winery, cut down the orchard on the front of his property to build the Camino Bowl on El Camino Real. The bowling alley featured 24 lanes and a restaurant named the Bowlero Room. The bowling alley was shut down in 1997 and replaced by the Gemello Village, a mixed-use commercial and housing development.

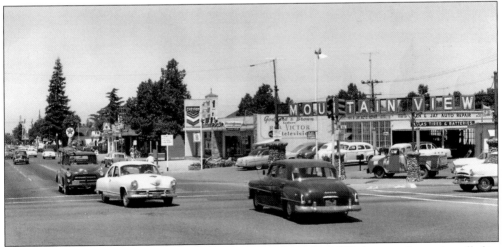

The large electric "Mountain View" sign, located at right of this 1957 photograph, was installed in 1920 at El Camino Real's intersection with Castro Street to notify drivers that they were passing by Mountain View's downtown. At the time, the downtown business district did not yet extend to El Camino Real and the sign stood amidst orchard trees. The sign and its twin across Castro Street were removed by 1962. (Courtesy MVPL.)

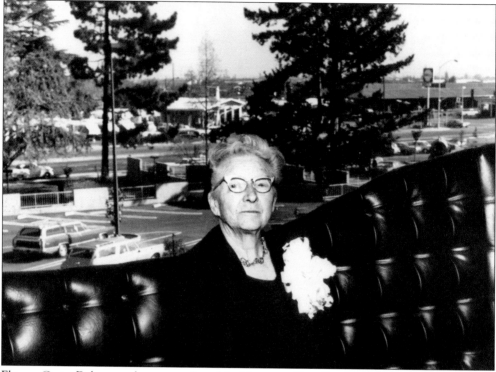

Eleanor Carter Dale was a charter member of the Mountain View Pioneer and Historical Association (now the Mountain View Historical Association). She is pictured here in the restaurant of the newly opened Emporium Department Store in 1970. The Emporium and the Americana Apartments behind it were built on the last acreage of the historic Dale Ranch. (Courtesy MVHA.)

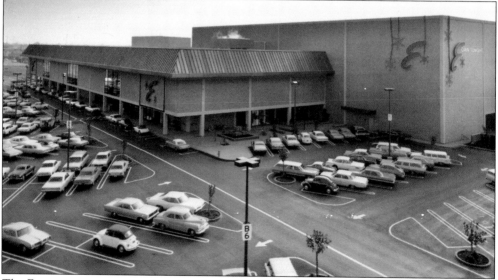

The Emporium was a major shopping destination for Mountain View residents from 1970 until 1995, when the San Francisco–based department store chain folded. In the late 1990s, residents successfully fought Home Depot's plans to build a big-box warehouse store on the site. Instead a new building for the Camino Medical Group will open on the site in 2007. (Courtesy MVPL.)

Rebecca and Dean Riggs opened Linda's Drive-In on El Camino Real at Escuela Avenue in 1956. Named after their daughter, the drive-in became locally famous for its unique Parisian burger and tater tots. This photograph shows Linda's shortly after its closure was announced in 1985. To this day, some longtime Mountain View residents strive to recreate the secret special sauce used on the much-missed Parisian burger. (Photograph by Sandra Khoury; courtesy MVPL.)

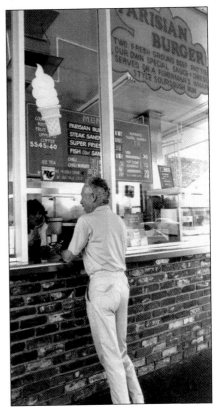

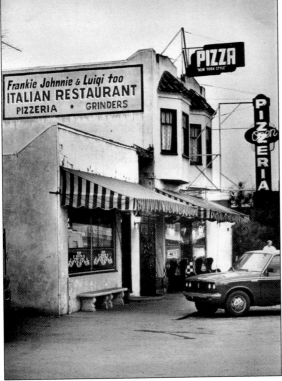

Restaurants come and go at quite a brisk pace, but every town seems to have a few that stick around for generations. Frankie, Johnnie, and Luigi Too Italian Restaurant has become a Mountain View institution. Brothers Frankie and Johnnie D'Ambrosio, along with their cousin Luigi D'Ambrosio, opened the ever-popular restaurant in 1957. The restaurant claims to be the first pizzeria on El Camino Real. (Photograph by Joe Melena; courtesy MVPL.)

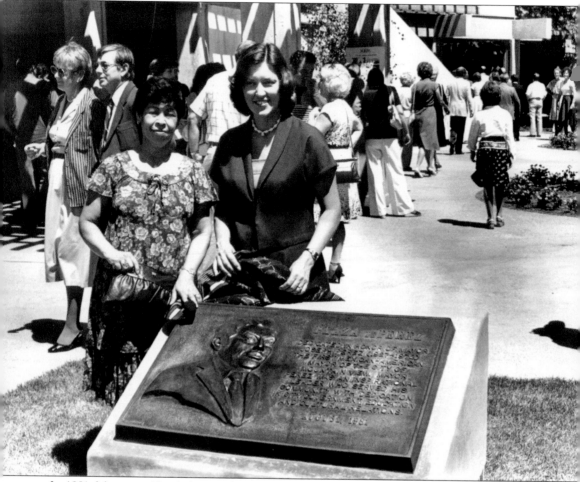

In 1981, Mountain View's first modern mixed-use housing and commercial development, Two Worlds, was erected on the site of the old Highway School. Few know that a small park-like plaza located on the complex's El Camino Real frontage is named in honor of Mountain View's first Mexican American council member and mayor, Joe Perez. Only four years after being elected to the council, Perez tragically died from cancer in 1978. Pictured here is his widow Emma Perez (left) standing in Plaza de Perez with councilmember Marilyn Perry (right) in front of the plaque erected by the project's developers in Perez's honor. The Two Worlds development is an early example of the types of projects that are transforming El Camino Real. This time, the strip malls are giving way to mixed-use housing, commercial, and office projects. Already one can see a glimpse of a more dynamic future that is likely in store for the venerable old highway. (Courtesy MVPL.)

Three

DOWNTOWN AND OLD MOUNTAIN VIEW

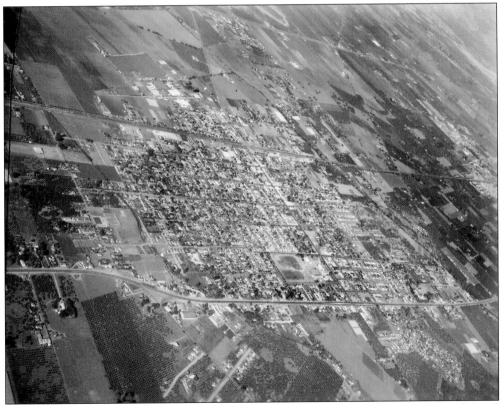

Although the term "Old Mountain View" initially applied to the now nonexistent town located along El Camino Real, today it is more commonly associated with the area pictured in this c. 1950 aerial photograph, which is the central portion of the city built before World War II. With downtown Castro Street at its core, Old Mountain View has become the historic, civic, and cultural heart of the city. (Courtesy MVPL.)

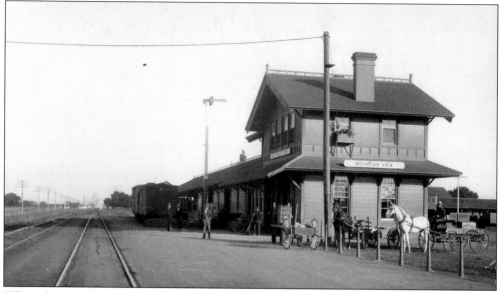

When the San Francisco and San Jose Railroad Company's first train rolled into Mountain View in 1864, travelers had to use a box car as a depot. It was not until 1888 that this landmark Southern Pacific Train Depot was built. The original depot building was demolished in 1959, but a replica was constructed nearby as a part of the celebration held in 2002 to honor the centennial of the city's incorporation. (Courtesy MVHA.)

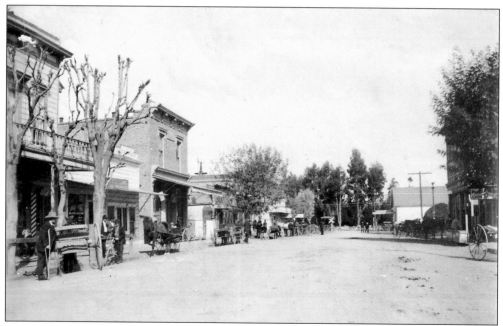

Simple wooden structures line an unpaved Castro Street in this *c.* 1895 photograph taken from the 100 block looking north toward the railroad tracks. The first few blocks of Castro Street were plotted by the Castro family's lawyer, Sherman Houghton, in the 1860s. Houghton was paid by the Castros with 500 acres of land in 1864, much of which now constitutes the city's downtown. (Courtesy MVHA.)

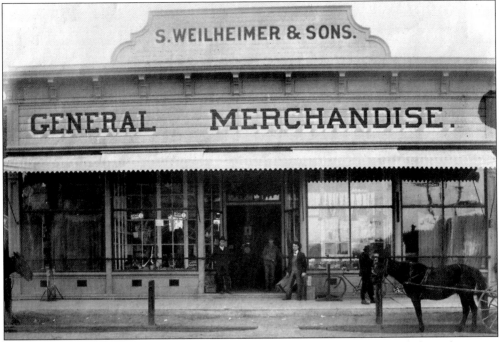

In 1874, brothers Samuel and Seligman Weilheimer opened a second branch of their El Camino Real General Store near the New Mountain View train depot on Castro Street. Pictured here is the store in 1896 after it was doubled in size. Seligman's son Julius took over the store after his father and uncle's death. The c. 1894 Julius Weilheimer house on Villa Street is currently home to the Chez TJ Restaurant. (Courtesy MVHA.)

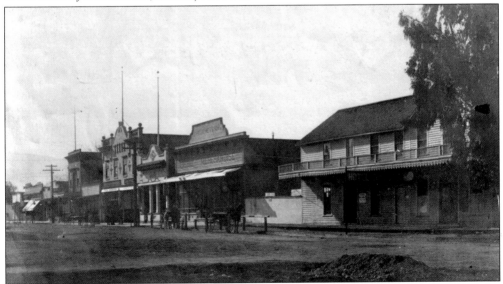

This view shows the 100 block of Castro Street around 1904. The building at center is the Weilheimer General Store and at right is the family's hotel. The hotel building, originally constructed in 1864, was the first in New Mountain View's history. In the 1910s, a portion of the hotel was relocated across the railroad tracks to 906 Washington Street, where it was used as an apartment complex until it was demolished in 2003. (Courtesy MVHA.)

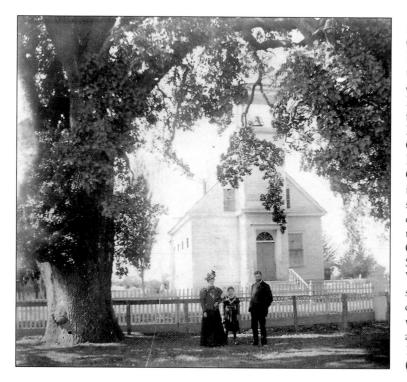

In 1852, 17 Cumberland Presbyterians met under a grove of oaks to organize Mountain View's first church. The Mountain View Cumberland Presbyterian Church was built in 1860 near that same oak grove on what is now the corner of Castro and Church Streets. Reverend Whittemore stands in front of the church with his daughter and wife in this 1898 photograph. (Courtesy MVHA.)

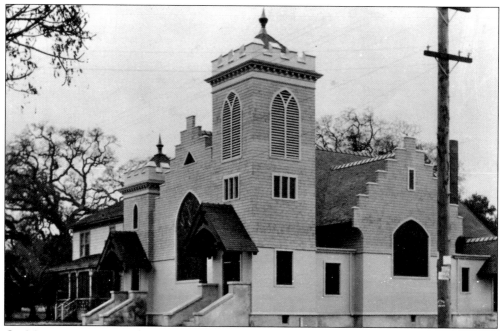

On May 14, 1911, an overheated stovepipe set the Presbyterian Church on fire. All that could be salvaged was the organ, the pews, the pulpit, some chairs, and the belfry bell. On January 19, 1913, this new church building was completed on Castro Street between Mercy and Church Streets. The new church served the congregation until it was declared unsafe and condemned in 1948. (Courtesy MVHA.)

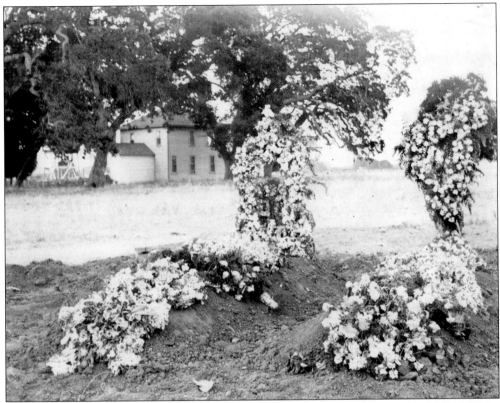

On March 19, 1861, Maria Trinidad Peralta de Castro donated five acres of the family's rancho to the Presbyterian Church for the establishment of a nondenominational cemetery. The Mountain View Cemetery, pictured here around 1900, was located adjacent to the Presbyterian Church and served the community until 1905. In 1930, the cemetery was donated to the city in exchange for tax payments. Today Pioneer Memorial Park occupies most of the site. (Courtesy MVPL.)

Today few realize that the peaceful Pioneer Memorial Park derives its name from the pioneers who are still resting beneath its rolling lawns. Only some of the bodies located in the Mountain View Cemetery were disinterred after its closure. Remains from 29 graves were uncovered during the construction of the new Mountain View Public Library's underground parking garage. They are pictured here being reburied near the park's Church Street frontage in 1996. (Courtesy MVPL.)

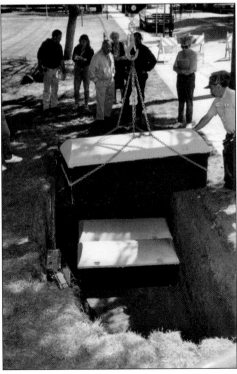

In 1882, Dr. D. D. Johnson opened Mountain View's first pharmacy on the 100 block of Castro Street. The simple one-story wooden structure is pictured here around 1896. The building was also home to Mountain View's first telephone office. (Courtesy MVHA.)

Local farmer John W. Barney lost his right leg in a timber-related accident around 1880. Unable to work the fields, he found a new job as Mountain View's postal carrier, serving 150 families along a 25-mile route. Unfortunately, when the postal service began using automobiles, Barney's disability prevented him from operating the new machines and his career as postal carrier came to an end. (Courtesy MVHA.)

The Pioneer blacksmith shop was built in 1888 on the northeast corner of Castro and Villa Streets. The blacksmith shop was originally owned and operated by Jacob Mockbee. The structure pictured here was destroyed by fire on October 9, 1895. The McDonald and Burke Blacksmith was built on the same site after the fire. (Courtesy MVHA.)

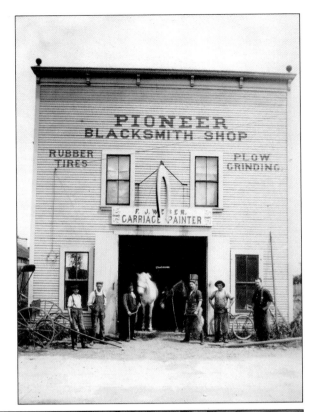

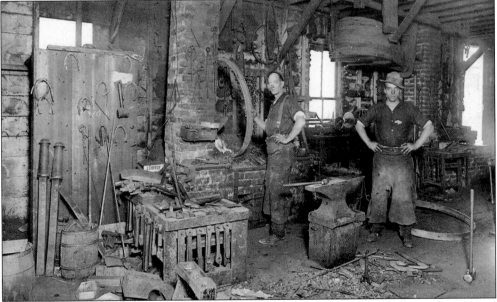

Dan Burke (left) and Louis Conti (right) are pictured here working inside the McDonald and Burke Blacksmith. In 1906, the blacksmith shop relocated to the 300 block of Castro Street, where it remained a fixture of downtown until the 1940s. Burke served on the city council from 1936 to 1946 and was mayor from 1937 to 1942. The house of his business partner Richard McDonald still stands at 696 California Street. (Courtesy MVHA.)

The house standing at 711 Calderon Avenue looks today much as it did around 1900 when it was built for town pharmacist Edward T. Johnson (not be confused with other town pharmacist at the time, Dr. D. D. Johnson). E. T. Johnson's pharmacy was one of the first tenants in the Jurian Building on the northwest corner of Castro and Villa Streets. The Jurian Building still stands today, with the 1913 date of construction displayed prominently on its parapet. (Courtesy MVHA.)

This Queen Anne Victorian at 1114 Villa Street was built in 1897 for judge Benjamin E. Burns and his wife, Kate Henley Burns. Judge Burns was a prominent local leader who served on Mountain View's first board of trustees from 1902 to 1910 and was the town's second mayor from 1904 to 1906. Remodeling efforts have wiped away much of the fine detailing of the home that is now divided into apartments. (Courtesy MVHA.)

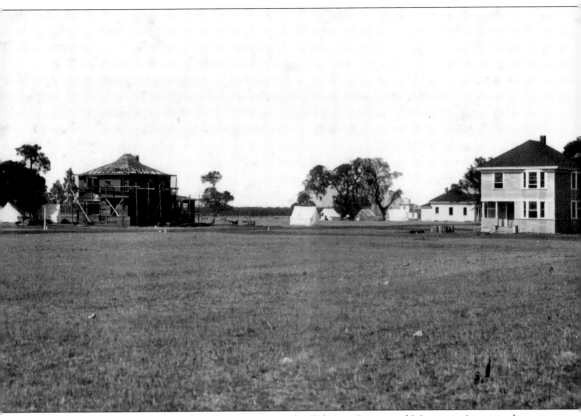

This c. 1900 photograph shows the intersection of California Street and Mariposa Avenue when it was a remote location at the western edge of town. Today this busy intersection is in the middle of the city. The three homes pictured, 1610 California Street (under construction at left), 1560 California Street (right), and 336 Mariposa Avenue (in the distance), are all still standing. Originally this neighborhood was to become an area of large country estates, but over the years it was subdivided into smaller lots and primarily built up with modest bungalows. The house at 336 Mariposa Avenue is perhaps the most prominent example of a home from the earlier era. It was built as the residence of Wilbur Camp, one of the owners of Mountain View's Farmers and Merchants Bank. The house at 1560 California Street is notable for being the Community School of Music and Arts' first home in the 1960s. (Courtesy MVHA.)

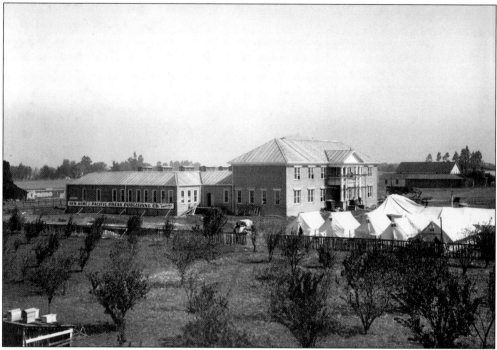

In 1904, the western half of Old Mountain View was changed forever by the relocation of the Oakland-based *Pacific Press* Seventh-day Adventist publishing company. The *Pacific Press* built an impressive 60,000-square-foot plant between Villa Street and the railroad tracks. The arrival of about 100 Adventist families spurred the growth of the residential neighborhood along Mariposa, Pettis, Palo Alto, and Mountain View Avenues. (Courtesy MVHA.)

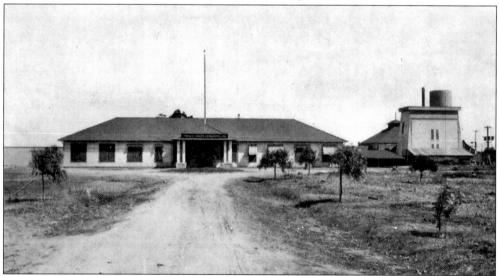

Only two years after completing their $40,000 plant, the Adventist community suffered a major blow when the structure was damaged by the 1906 earthquake and destroyed by fire two months later. The modest new plant pictured here was built on the same site following the fire. *Pacific Press* relocated to Idaho in 1983. When the property was redeveloped, this structure and the plant's auditorium building were saved and converted for office use. (Courtesy MVHA.)

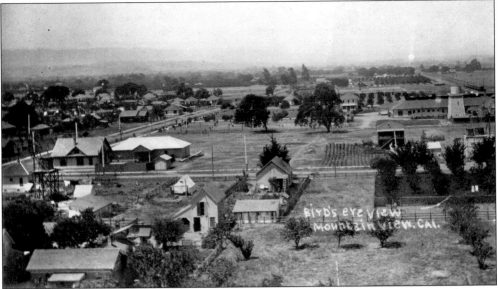

Bailey Avenue (now Shoreline Boulevard) runs through the center of this 1909 bird's eye view of Mountain View. At far right stands the water tower and publishing plant of the *Pacific Press*. At left large old oak trees shade the new homes built south of Villa Street for *Pacific Press* employees. (Courtesy MVHA.)

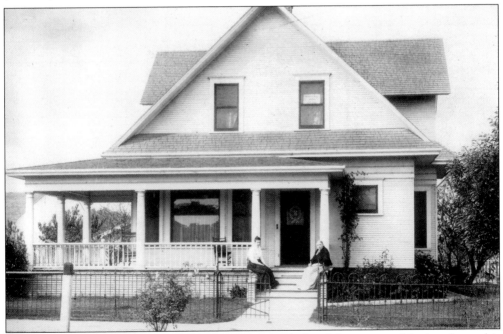

One of the earliest homes constructed in the Seventh-day Adventist neighborhood was this house on Palo Alto Avenue, built in 1907 for Reverend Hampton W. Cottrell, president of *Pacific Press*. The landmark structure was nearly demolished before the adoption of Mountain View's temporary historic preservation ordinance in 2002. After a great deal of discussion and debate, the exterior was saved, while the interior was replaced with a modern wheelchair-accessible home. (Courtesy MVHA.)

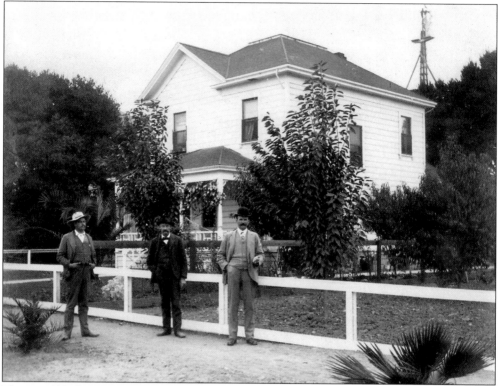

Thomas Able Rogers came to Mountain View from Ohio in 1890. He is pictured here (at center) standing in front of his family's home on Hope Street. Rogers and his wife, Olive Pride Rogers, raised their three children in this house. Their son Alvin served as Mountain View's first city treasurer from 1902 to 1914. (Courtesy MVHA.)

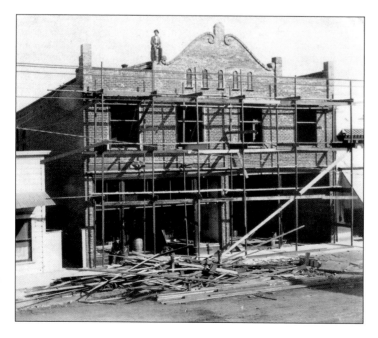

In 1894, Thomas A. Rogers and his nephew Arthur B. Rogers opened the Rogers and Rogers General Store on the 100 block of Castro Street. Pictured here is the store building during its enlargement in 1903. As the 20th century approached, Castro Street began to shed its frontier-town image as its simple wooden buildings were replaced by more substantial two-story brick structures like the new Rogers and Rogers Building. (Courtesy MVHA.)

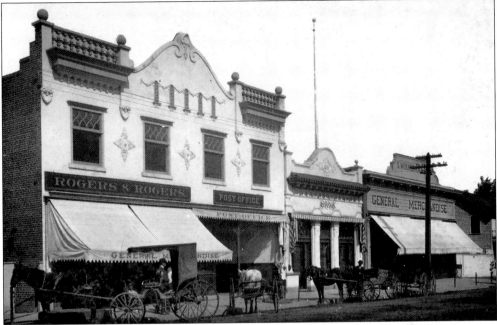

This *c.* 1905 photograph of the 100 block of Castro Street shows the Rogers and Rogers Building after it was expanded. Next door is the city's first bank, the Bank of Mountain View. The only structure in this photograph still standing is also the oldest commercial structure in the city, the venerable *c.* 1874 Weilheimer General Store building at far right. (Courtesy MVHA.)

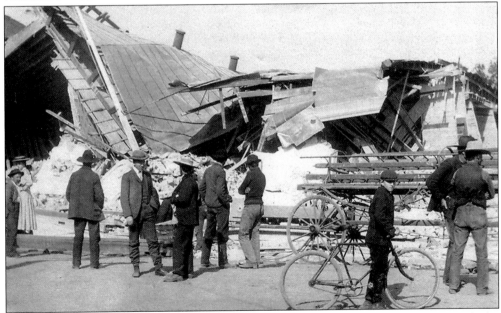

On April 18, 1906, the great earthquake that destroyed much of San Francisco wreaked a considerable deal of havoc on the tiny city of Mountain View as well. This postcard, produced and sent only a few days after the quake, shows the Rogers and Rogers Building reduced to a pile of rubble. As pictured in the subsequent series of photographs, many of Mountain View's brick structures faced similar devastation. (Courtesy MVHA.)

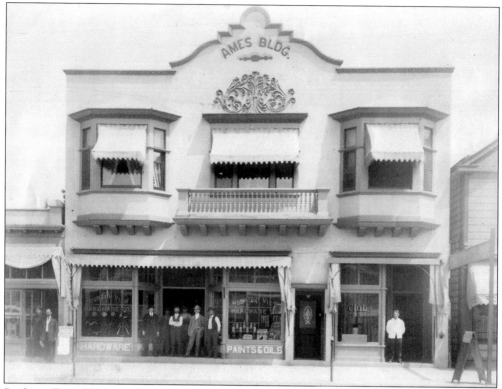

Professor Daniel T. Ames, a nationally renowned handwriting expert, built the Ames Building in 1903. Professor Ames resided on the second floor of the structure and the first floor housed two businesses. In this early photograph, the Mountain View Hardware Store and the Club Restaurant occupy the two ground-floor tenant spaces. (Courtesy MVHA.)

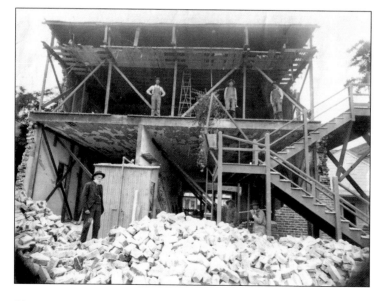

Professor Ames stands amidst the fallen bricks of the rear wall of his building after the 1906 earthquake. The building was quickly repaired. For many years it has been home to the Jehning family's locksmith. In 2003, the Jehnings restored the facade to its original appearance, and in 2005 they opened the Jehning Family Lock and Key Museum in its second storefront. (Courtesy MVHA.)

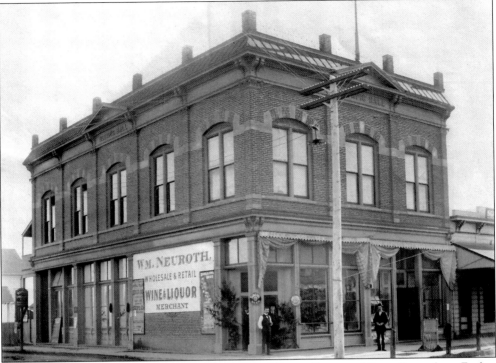

Olympic Hall was located on the southeast corner of Castro Street and Front Street (now Evelyn Avenue). Built in 1888, the two-story brick structure was an early location for the city's post office. The second floor was home to a popular community gathering spot for dances and performances. (Courtesy MVHA.)

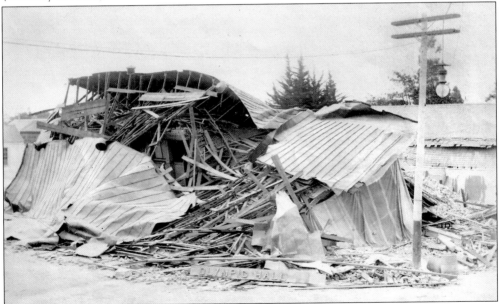

The 1906 earthquake had an interesting effect on Olympic Hall. The second floor was destroyed forever when it slid off and came crashing to the ground, producing the pile of wood and bricks seen here. The first floor of the building was rebuilt and stood on the site until 1963. (Courtesy MVHA.)

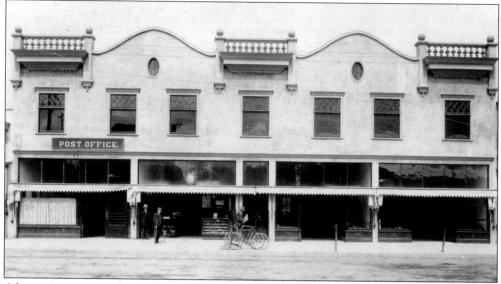

After seeing so many brick structures collapse, Thomas Rogers and Arthur Rogers decided to use concrete to rebuild their structure. The new Rogers Building featured four storefronts on the ground floor and the Mountain View Hotel on the second. The building, located at 142–146 Castro Street, has gone through many facade remodels. The most recent, completed in 2005, offers a modern interpretation of the original facade. (Courtesy MVHA.)

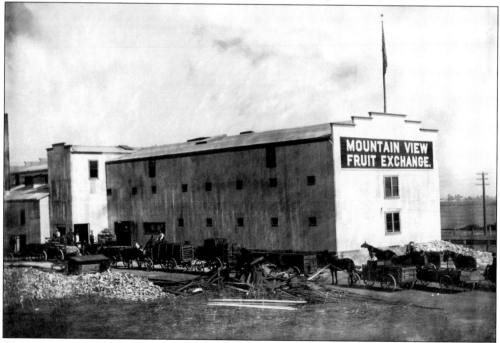

The Mountain View Fruit Exchange Company opened in 1903 in a warehouse originally owned by the Bubbs, one of Mountain View's earliest families. The fruit packing and storage facility was completely leveled by the April 1906 earthquake but by the time this September 19, 1906 photograph was taken, the structure had been rebuilt. The three-story Fruit Exchange was located at the end of Oak Street alongside the railroad tracks. (Courtesy MVHA.)

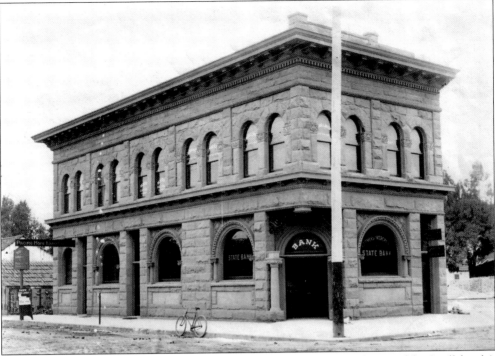

The Farmers and Merchants Bank Building was completed in 1905 on the site of the Swall family's meat market at the southeast corner of Castro and Villa Streets. The sturdy sandstone structure was left relatively unscathed by the 1906 earthquake. The Farmers and Merchants Bank became a branch of the Bank of Italy (now Bank of America) in 1926. (Courtesy MVHA.)

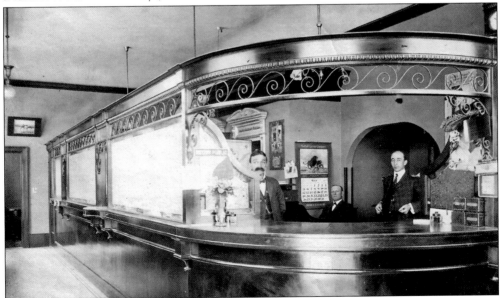

The Farmers and Merchants Bank's three main partners pose behind the counter in this 1907 interior view of the structure. They are, from left to right, Julius Weilheimer, Jacob Mockbee, and Wilbur Camp. A bank occupied the building until 1955. Thereafter it was occupied by meat market and, in recent years, the Red Rock Coffee Company café. (Courtesy MVHA.)

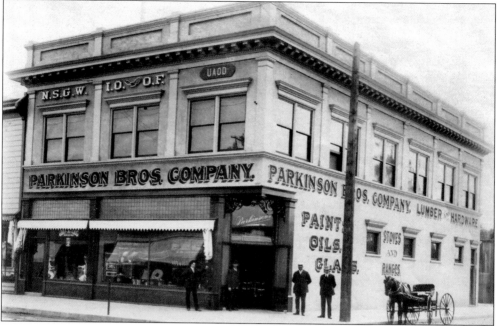

In 1906, Jacob Mockbee replaced the McDonald and Burke Blacksmith Shop with this handsome structure on the northeast corner of Castro and Villa Streets. The second floor of the Mockbee Building was home to meeting rooms used by a variety of local fraternal organizations, including the Native Sons of the Golden West and the International Order of Odd Fellows. The bottom floor was home to Parkinson's Hardware until 1962. (Courtesy MVHA.)

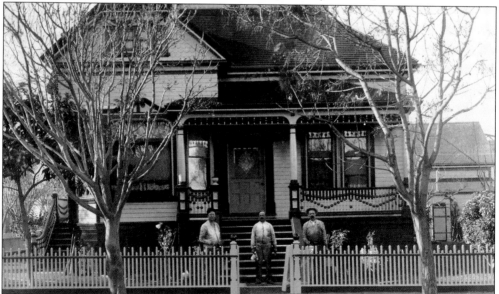

Jacob Mockbee lived with his wife, Emma Wagner Mockbee, in this Victorian home on the northwest corner of Hope and Villa Streets. In addition to being a founding member of the Farmers and Merchants Bank, Mockbee served as an early town trustee and as mayor from 1916 to 1918. He was one of 11 children raised by James Mockbee and Clarissa Boone Mockbee in Mountain View. Clarissa was a direct descendent of the famous Daniel Boone family. (Courtesy MVHA.)

In 1907, George Swall constructed this commercial building as the new home for his meat market after the Farmers and Merchants Bank was constructed at its original location. The second floor, for a time known as Swall Opera Hall, was used as a social hall but was later removed. The first floor still stands as a part of a modern three-story building at 219 Castro Street. (Courtesy MVHA.)

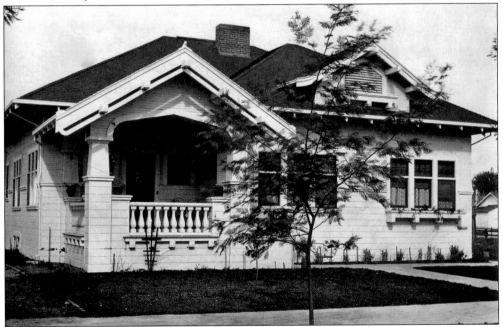

George Swall built this home, which still stands at 344 View Street, for his family in 1908. Wolf and McKenzie of San Jose designed the house. In addition to owning a meat market, Swall was one of Mountain View's original Town Trustees from 1902 to 1911. (Courtesy MVHA.)

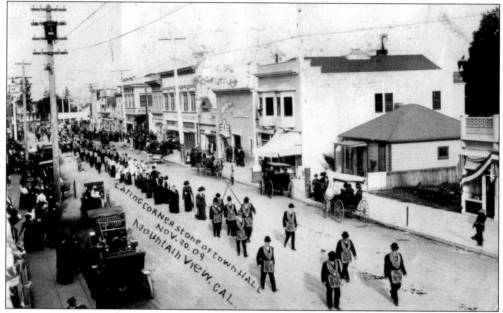

Mountain View incorporated as a city on November 2, 1902, with a population of 610 residents. On November 30, 1909, the Mountain View's civic leaders paraded down Castro Street to celebrate the laying of the cornerstone of Mountain View's new city hall on the southeast corner of Castro and California Streets. This postcard shows the parade as it makes its way down the 200 block of Castro Street. (Courtesy MVHA.)

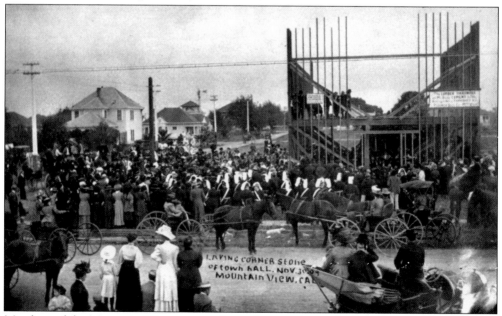

Members of the Mountain View community gather to witness the laying of the new city hall's cornerstone. The home in the distance and to the left of the construction site is the house of blacksmith Richard McDonald at 696 California Street. The two-story home at far left later became the site of the c. 1925 California Apartments, Mountain View's first modern apartment building. (Courtesy MVHA.)

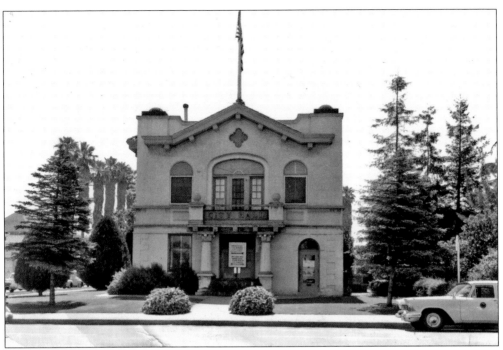

In addition to city government offices, city hall was home to the police department, a small jail, and the public library. City offices outgrew the building in 1959. The structure is pictured here a few years before it was torn down in 1962. (Courtesy MVPL.)

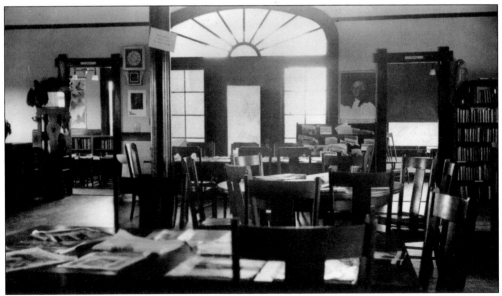

When the 1910 city hall was built, the public library was located on the first floor of the building. This photograph shows the interior of the library after it moved to the second floor in 1926. The center windows looked out over Castro Street. The Mountain View Public Library remained here until 1952. (Courtesy MVPL.)

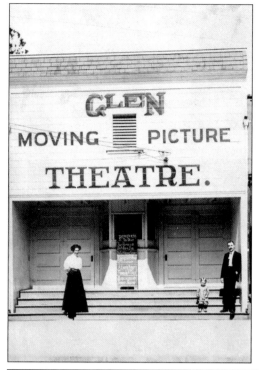

Evidence of Mountain View's growing prosperity can be found in the number of less practical businesses that began to join the blacksmith shops and general stores lining Castro Street in the early 1900s. One such business was the Glen Theatre, which opened in 1909 in the Swall Building. The Campen family built this new home for the Glen Theatre at 174 Castro Street in 1910. (Courtesy MVHA.)

This snapshot shows a close-up view of the entrance to the Glen Theatre where a group of patrons appear to be waiting for a show. Posters advertise the new motion pictures that the ticket booth claims "changed to-day." Admission prices were 15¢ for adults and 10¢ for children in 1917. The theatre was expanded and a Wurlitzer organ was added in 1921. (Courtesy MVHA.)

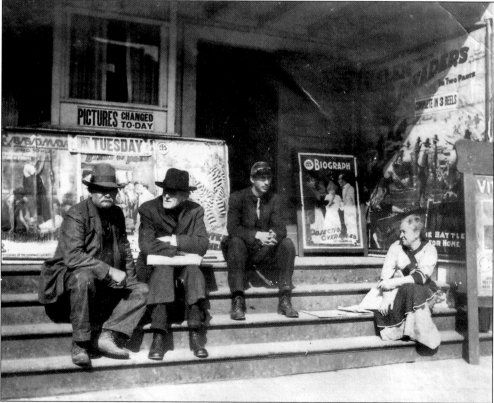

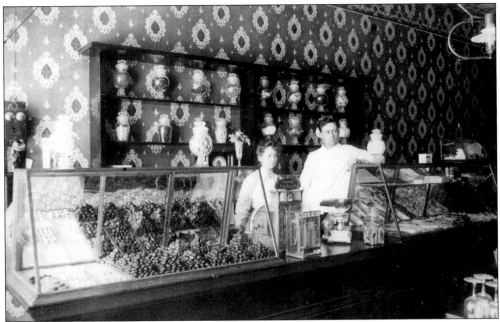

Fred and Genevieve Lovejoy stand behind a counter full of sweets inside the Lovejoy Candy Store and Ice Cream Parlor in 1909. In 1917, the *Mountain View Register Leader* reported that the store's new electric popcorn machine was "the biggest sensation the town has ever had seen since Johnny McCleary's bull died." (Courtesy MVHA.)

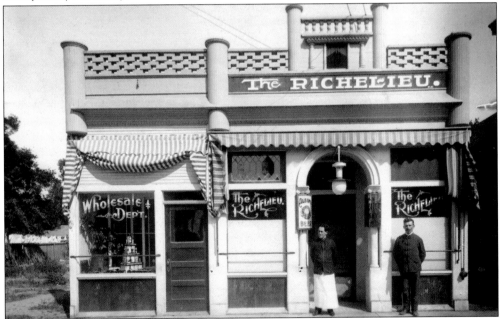

Mountain View has always had its fair share of saloons. This castle-like structure at the northeast corner of Castro and Dana Streets housed the Richelieu Saloon and Liquor Store. Louis Tambini, an Italian immigrant who came to Mountain View in 1884, operated the saloon. The Richelieu was described in the June 28, 1907, edition of the *Mountain View Leader* as a "simple room, where beverage forms the leading attraction." (Courtesy MVHA.)

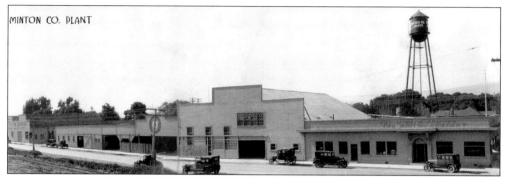

MINTON CO. PLANT

Minton Lumber Company is Mountain View's oldest continuously operating commercial establishment. The business was founded on May 15, 1911, when Earl D. Minton purchased the Parkinson Brother's Lumberyard on Front Street. Many of Old Mountain View's original homes were built by Minton Lumber Company, including the homes in the c. 1924 Palmita Park neighborhood along Loreto and Velarde Streets. Pictured here is Minton's large plant sometime in the 1920s. (Courtesy MVHA.)

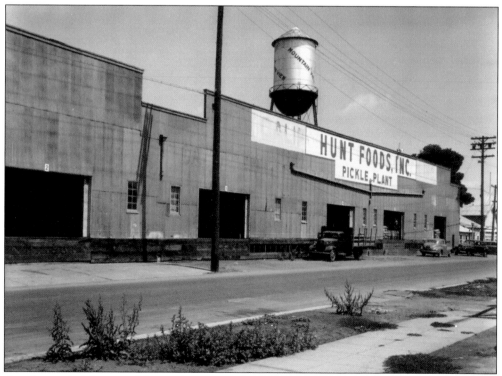

Another early Mountain View industry was the California Supply Company on Franklin and Villa Streets, known simply since its opening in 1915 as the "Pickle Works." Hunts Foods owned the pungent pickle-packing plant when this photograph was taken in 1951. It was demolished in 1963 and the site is now home to the Mountain View Police and Fire Administration Building. (Courtesy MVPL.)

As Mountain View continued to prosper, new schools and civic buildings were built to serve the growing population. In 1916, Dana Street School was built on the corner of Dana Street and Bailey Avenue (now Shoreline Boulevard). The building was condemned in 1955 and demolished in 1960. The site is now the location of the Mountain View Fire Department's Station No. 1. (Courtesy MVHA.)

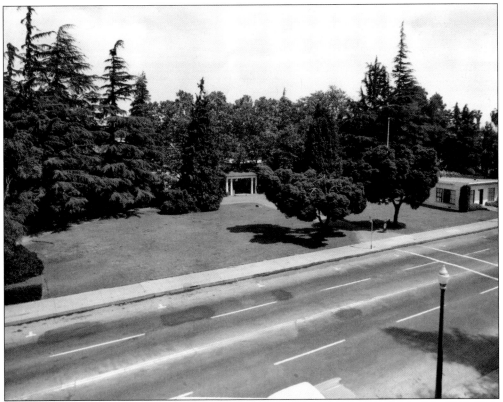

Mountain View's first city park was built on Castro Street beside the old city hall in 1923. This photograph shows the park with its pergola at center and the Mountain View Chamber of Commerce Building at far right. The little park was sold and replaced by a commercial development shortly after this 1961 photograph was taken. (Courtesy MVPL.)

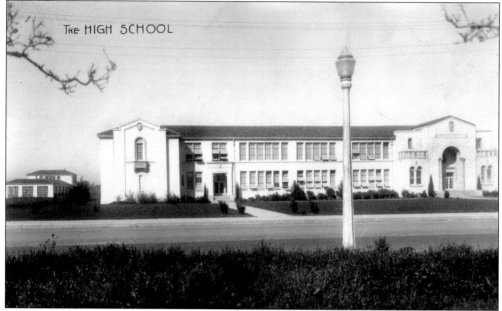

In 1924, Mountain View residents proudly opened the doors of the new Mountain View Union High School at 650 Castro Street. The landmark Mission-style structure was designed by renowned Californian architect William H. Weeks and included a fully equipped 750-seat auditorium theatre. It replaced the first high school on El Camino Real, but retained the old school's blue and gray colors and eagle mascot. (Courtesy MVHA.)

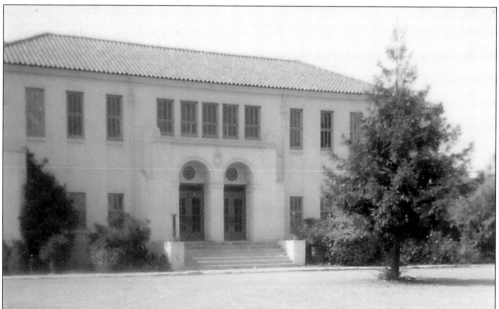

The main gymnasium was completed in 1927. The words of the alma mater were heard in these walls countless times, "In valley rimmed with mountains, covered by a sky of blue, stands our Alma Mater high school, with her colors brave and true. May her standards never waiver, as we onward go each day, we'll fight for dear old Mountain View, and her colors blue and gray!" (Courtesy MVHA.)

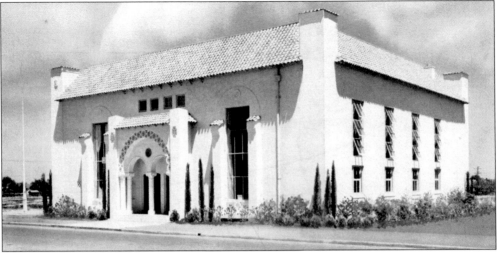

Many buildings near the new high school adopted its Mission-style architecture. Perhaps the most notable example is the Mountain View Masonic Temple, originally built in 1932 as the American Legion Memorial Hall. The Masons purchased the structure in 1936. The Mountain View Masonic Lodge was founded in 1868, making it one of the northern Santa Clara Valley's oldest fraternal organizations. (Courtesy MVHA.)

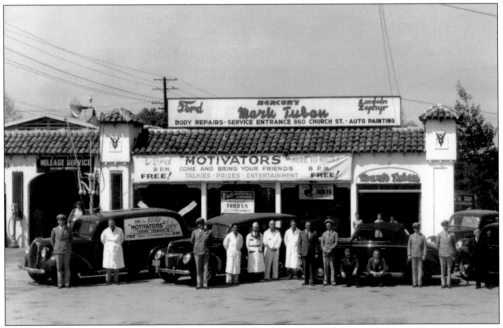

Another example of Mission-style architecture near the high school was this Ford dealership on the corner of Castro and Church Streets. Mark Tuban owned the dealership by the time this photograph was taken. Tuban came to the United States from the Ukraine in 1912 at the age of 15. After fighting in World War I, he met Henry Ford, who set him on globetrotting career path selling Ford motor vehicles before settling down in Mountain View. (Courtesy Trudi Tuban.)

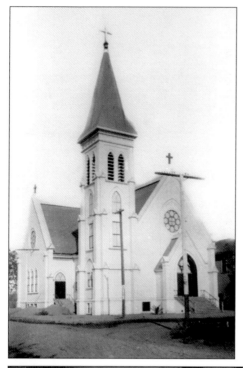

The first St. Joseph's Catholic Church was built in 1867 near El Camino Real at Stevens Creek. When the church formally organized in 1901, it served not only Mountain View but also the cities of Sunnyvale, Los Altos, Mayfield, and Palo Alto. In 1905, St. Joseph's moved out of its modest chapel in Old Town and into this new church built on land donated by the Castro family at the northwest corner of Hope and Church Streets. (Courtesy MVHA.)

Sunlight filters in through the windows of St. Joseph's in this interior photograph. The 1905 church was decorated with ornately painted walls and stained-glass windows. The church received its pipe organ from St. Ignatius Church in San Francisco after that church was destroyed by the great quake and fire of 1906. (Courtesy MVHA.)

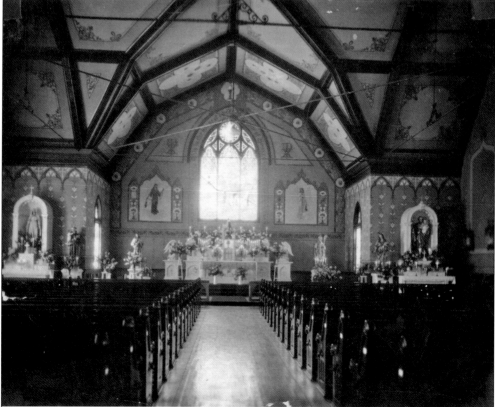

The old St. Ignatius pipe organ survived yet another blaze when an arsonist set fire to St. Joseph's Church on March 18, 1928. As this photograph shows, the rest of the church was not so lucky. (Courtesy MVHA.)

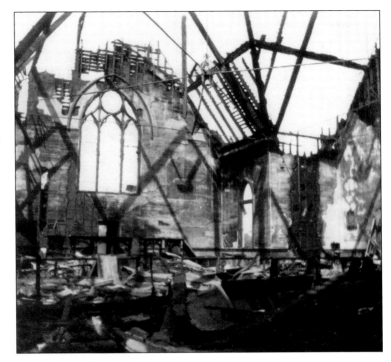

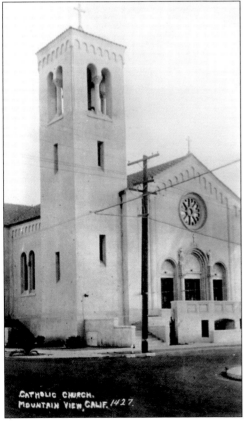

In 1929, a third St. Joseph's rose from the ashes of the second. The structure was similar to the one it replaced in both form and size, but sported a modern Mission-style architectural treatment. The building now stands as the oldest church in Mountain View. Recent restoration work and seismic strengthening of the church have helped ensure that St. Joseph's will continue to stand as a prominent downtown landmark. (Courtesy MVHA.)

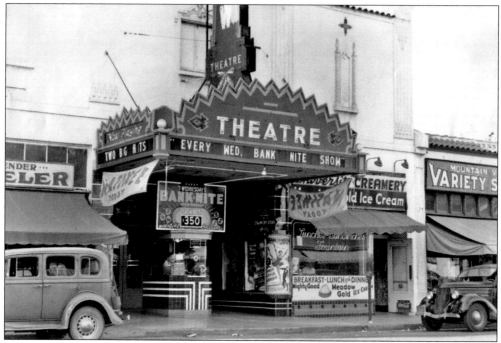

Anticipating the opening of Fritz Campen's new movie theatre in 1926, the *Mountain View Register Leader* declared, "The people of Mountain View are going to be mighty proud of this show house, and Mr. Campen is to be congratulated that he has waited until he was good and ready to give his home town so good and so beautiful a theatre." The Campen Theatre replaced the Glen Theatre, built by Fritz's father, as Mountain View's premier entertainment venue. (Courtesy MVPL.)

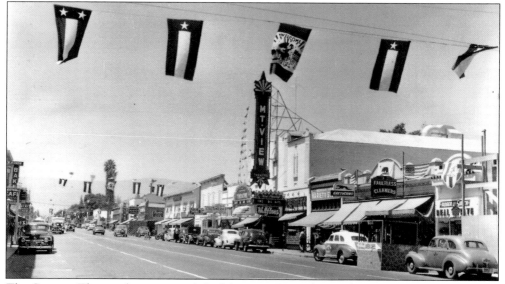

The Campen Theatre, later renamed the Mountain View, featured 750 seats, a pipe organ, and two stores facing Castro Street. Well known Bay Area architect and Mountain View resident A. A. Cantin designed the Mission-style building. Pictured here is the theatre and surrounding downtown buildings on the 200 block of Castro Street around 1950. The banners flying across the street were put up in honor of the city's Harvest Festival. (Courtesy MVPL.)

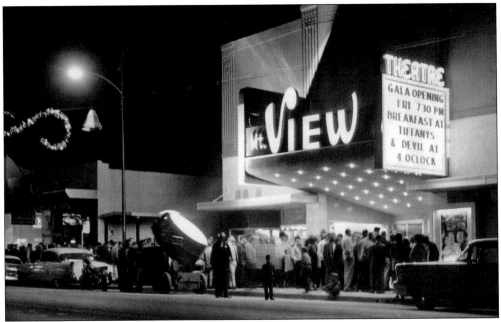

Lines wrapped around the block when the Mountain View Theatre celebrated its grand reopening in January 1962. Downtown's old movie palace was completely modernized, and a new neon blue marquee sign was installed over the sidewalk. The theatre closed in 1987 due to competition from multiplexes. Since the late 1990s, it has been used as a nightclub. (Courtesy MVPL.)

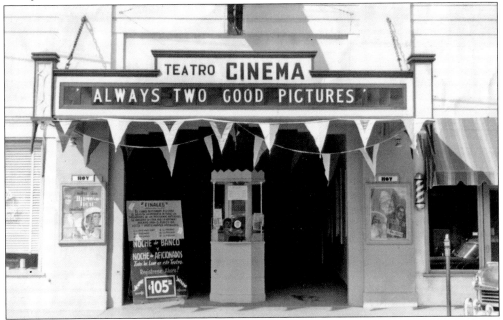

In 1934, Antonio Blanco opened the Cinema Theatre (later known as the Teatro Cinema) in a former auto dealership on Dana Street at Bryant Street. The theatre housed 650 seats on the ground floor and another 100 in the balcony. Sometime around 1940, the theatre adopted a Spanish-language format and became a social hub for the region's Spanish and Mexican communities. In 1955, the theatre was demolished by the city and replaced by a parking lot. (Courtesy MVHA.)

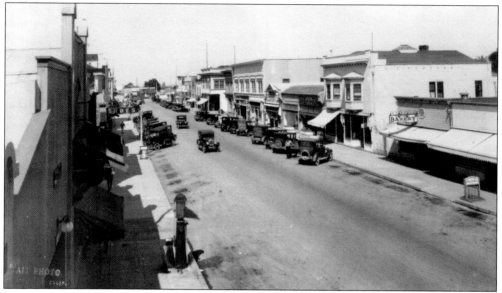

This 1927 bird's-eye view shows the 200 block of Castro Street looking north towards Villa Street. Mountain View's first Safeway Grocery Store can be seen in the one-story, tiled-roof building at right. At far right stands the California Bakery that eventually relocated to the Safeway Building. The bakery was a downtown institution from 1923 until 1997. (Courtesy MVHA.)

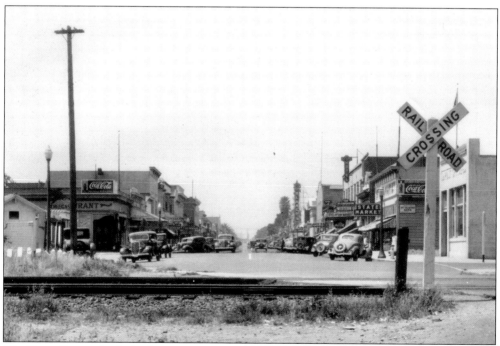

The Great Depression halted most new construction downtown. Building owners instead settled for less expensive improvements, which explains the profusion of neon signs popping up from buildings along the 100 block of Castro Street in this 1937 photograph taken from the railroad tracks. (Courtesy MVHA.)

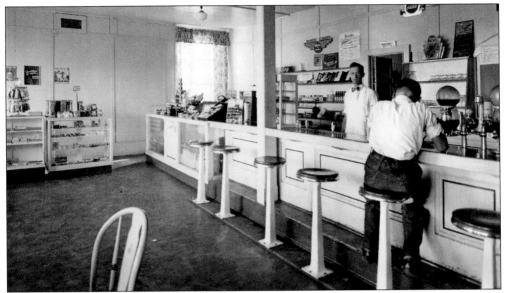

Co-owner Ormond Newfarmer stands behind the counter of the Silver Seal Creamery shortly after it opened in 1933 near the Campen Theatre. Originally the day's earnings were hidden in a bag similar to ones sold as candy grab bags. One day, the money bag was accidentally sold to a youngster who was later found tossing coins to his friends. Luckily, most of the cash was retrieved. (Courtesy MVHA.)

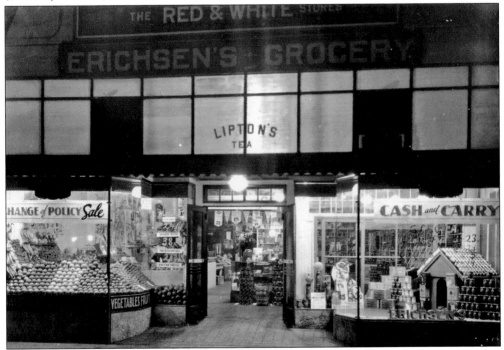

The display windows shine brightly in this night shot of Erichsen's Grocery taken in 1935. The grocery store was one of four tenants in the large Four Stores Building built on the northeast corner of Castro and Dana Streets in 1922. The building has been heavily modernized but still exists. (Courtesy MVHA.)

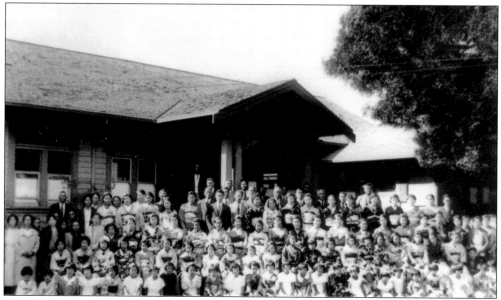

The 1934 class of Mountain View's Japanese Language School, the Nihongo Gakuen, stands in front of their building at 260 View Street. The school was founded in 1915 on Front Street and relocated to View Street in 1925. The school was reformed in 1959 after being disbanded during the World War II Japanese internment. The View Street Building was demolished in 1962. (Courtesy MVPL.)

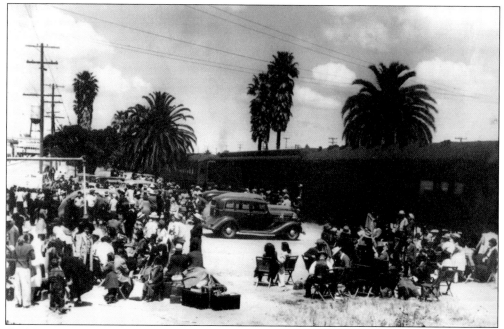

On May 26, 1942, Mountain View's Japanese community was sent via train to the Santa Anita Assembly Center in Southern California where they were then assigned to internment camps in Arizona, Colorado, and Utah for the duration of World War II. That dark moment in the city's history is captured in this photograph taken at the Mountain View train station as the area's Japanese families wait to board their trains. (Courtesy MVHA.)

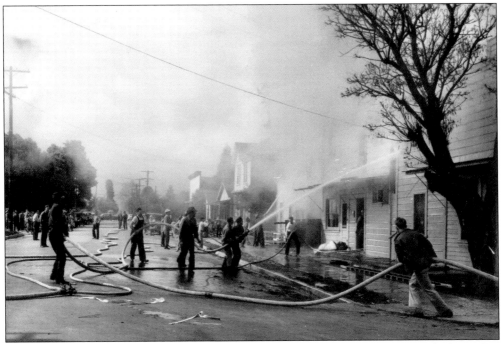

The Chinese presence in downtown Mountain View stretches all the way back to the late 1870s when a Chinatown district began to form at the intersection of Villa and View Streets. Chinatown is pictured here on April 1, 1946, when a large fire damaged a number of buildings. Over 60 people had to be evacuated, but no one was injured. (Courtesy MVHA.)

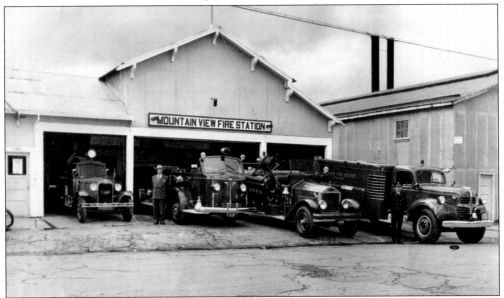

The Mountain View Fire Department traces its origins to a volunteer brigade formed on April 1, 1874. In 1924, this fire station building was constructed on Franklin Street. This photograph shows the fire station in 1950, the year the first paid firemen were hired by the city. In 1953, the fire station headquarters moved to a new building at the southeast corner of Villa and Franklin Streets. (Courtesy MVHA.)

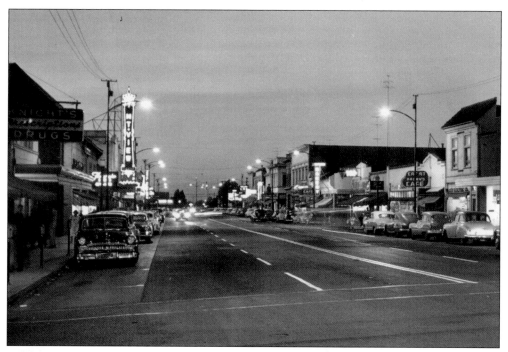

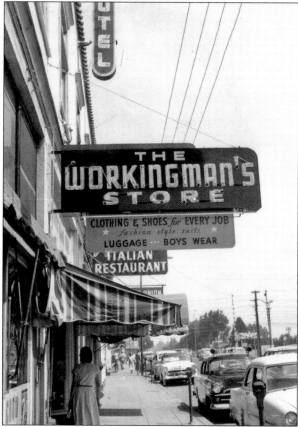

This early evening photograph of Castro Street, taken in 1953, shows a view of the 200 block similar to the one pictured on page 114. The simple two-story building at far right was built in 1904 as Mountain View's first town hall. Just beyond the Knight's Drugs sign at left is the J. C. Penney Department Store, which is now the location of longtime downtown business Meyer Appliance. (Courtesy MVHA.)

The Workingman's Store's neon sign juts out over the sidewalk in this c. 1954 photograph. Arnold and Mildred Kline opened the store in the Rogers Building in 1953. A few years later, it moved to the Weilheimer General Store Building where it served the needs of the city's blue-collar population well into the 1970s. Arnold and Mildred's son Terry is in the process of restoring the Weilheimer Building. (Courtesy Terry Kline.)

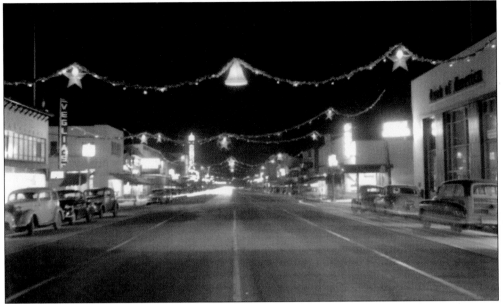

Castro Street takes on a festive glow in this December 1950 image taken near the intersection with Dana Street. Garlands with lit bells and stars cross over the street and the marquee of the Mountain View Theatre can be seen shining in the distance. The old-fashioned Christmas decorations have since been replaced by hundreds of white lights that decorate Castro Street's trees during the holidays. (Courtesy MVPL.)

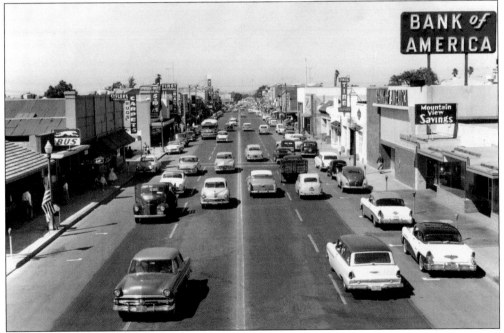

Castro Street looks like a mini-highway in this 1957 bird's eye view of the 300 block. With four wide lanes of traffic and two lanes of parking, the street served not only as the town's business district but also as its main north/south roadway. At the time, downtown was facing new competition from malls and shopping centers and was eager to shed its old-fashioned image. (Courtesy MVPL.)

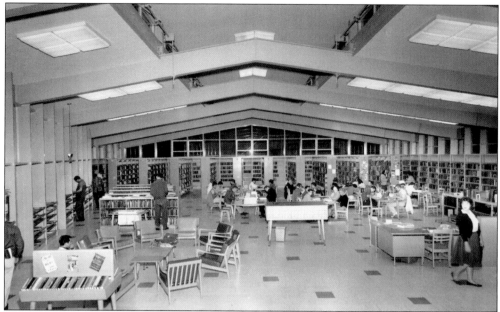

After the Mountain View Public Library left the old city hall in 1952, it relocated to a converted storefront at 939 Dana Street. On October 20, 1958, a new library was built on Franklin Street adjacent to the old Mountain View Cemetery. The 8,400-square-foot, one-story structure was capable of housing 97,000 books. The main floor of the library is pictured here in 1960. (Courtesy MVPL.)

In 1959, the Presbyterian Church sold the property it had owned since 1851 to the City of Mountain View. It relocated to Cuesta Drive at Miramonte Avenue and the eight-year-old church was converted into a new city hall. During its time as the council chambers, the church's circular stained-glass window featured Mountain View's city seal. The window is now displayed in the lobby of the current city hall. (Courtesy MVPL.)

In 1966, the library and city hall were united into a formal civic center when the old Mountain View Cemetery (located between the two buildings) was transformed into Pioneer Memorial Park. One of the park's most prominent features was this Japanese garden with its 10-foot-high granite waterfall and pond. In 1996, the waterfall and pond were removed from the park to accommodate a new building for the Mountain View Public Library. (Courtesy MVPL.)

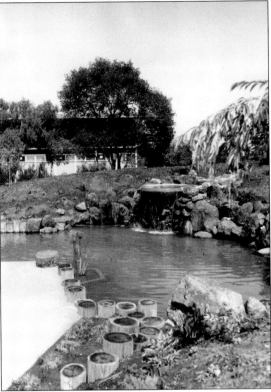

This c. 1960 image of Castro Street was taken on one of those days when it is clear why Jacob Shumway chose "mountain view" as the town's name. This photograph was taken just north of California Street looking towards El Camino Real. Narrow sidewalks, wide traffic lanes, and large colorful signs are all indicative of downtown's attempt to cater towards automobile drivers and compete with El Camino Real's new strip malls. (Courtesy MVPL.)

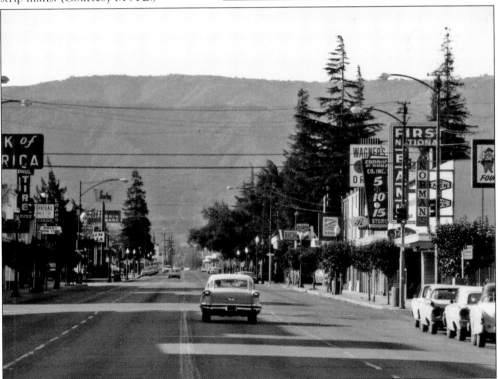

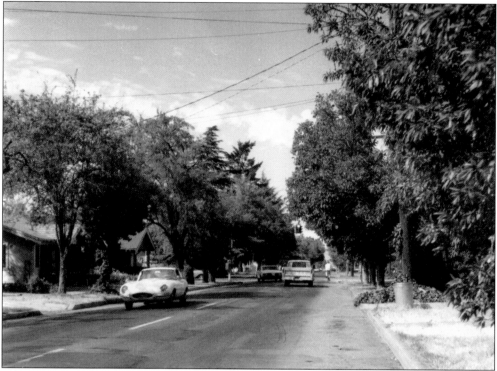

When this photograph of Bailey Avenue (now Shoreline Boulevard) was taken around 1960, the street was still a quiet two-lane thoroughfare lined with old bungalows and trees. City planners, however, had grand plans for the street. In 1969, it was widened into a six-lane boulevard with a large overpass and an interchange at Central Expressway. This image looks north towards California Street. (Courtesy MVPL.)

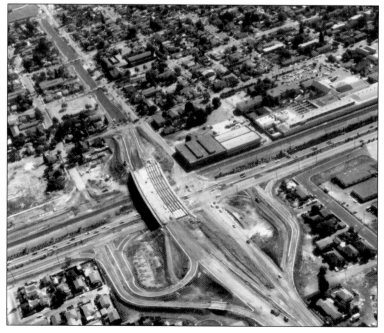

In 1969, the widening of Bailey Avenue and the construction of its interchange with Central Expressway tore apart a predominately Mexican American neighborhood located along Washington and Jackson Streets. Dozens of Latino families were forced to leave their homes during the midst of a housing crisis, and many were not able to afford to resettle in Mountain View. (Courtesy MVPL.)

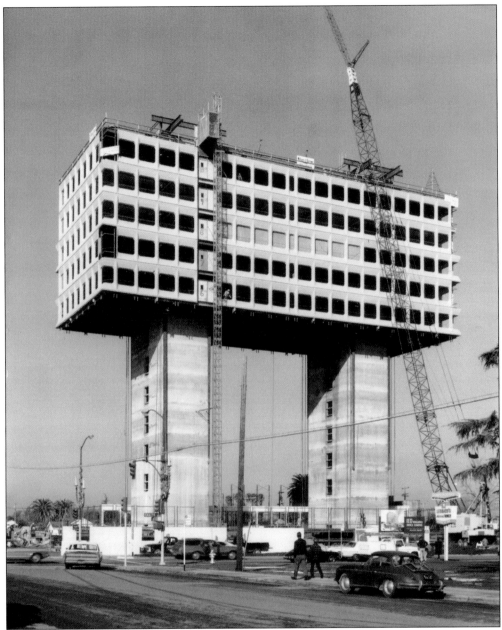

During the 1960s, civic leaders envisioned turning downtown into a modern city center filled with apartment blocks and high-rises. The International Environmental Dynamic (IED) Building, pictured here during construction in 1970, was the only high-rise to actually be built. It was constructed using a unique top-down method where the upper floors were suspended from its two core central towers. The building ran into a number of financial and legal problems, and construction halted for years. When it was finally completed in 1981, the 11-story tower sat vacant. Dogs were let loose on the ground floor to deter break-ins, earning it the nickname the "dog house" or "dog city." In the late 1980s, it became Mountain View's temporary city hall while the new civic center was constructed across the street. Today the building is known as Mountain Bay Plaza and it has finally achieved the level of success its builders hoped for. (Courtesy MVPL.)

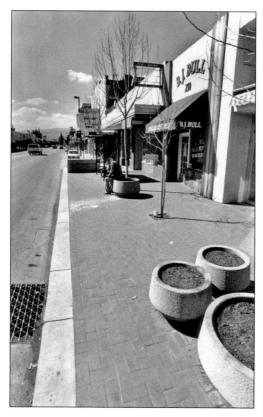

Castro Street appears quite desolate and bleak in this 1982 photograph of the 200 block. The only people on its narrow brick sidewalks are two souls waiting for a bus. By the 1980s, most shoppers had abandoned downtown for the malls. An influx of Asian (particularly Chinese) businesses kept downtown from becoming a complete ghost town during this era of its history. (Photograph by Sam Forencich; courtesy MVPL.)

A bit of holiday cheer is added to the Mountain View "cube" in this 1987 photograph. The happy little snowman gave some warmth to the austere cement cube that once welcomed drivers into downtown. The cube site, on the corner of Castro Street and Evelyn Avenue, is now home to Centennial Plaza. (Photograph by Joe Melena; courtesy MVPL.)

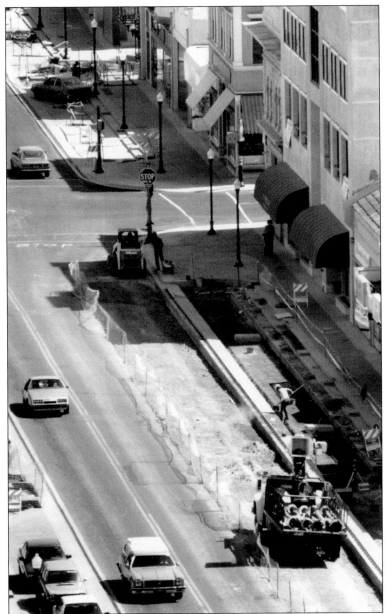

In 1990, the city pumped nearly $12 million dollars into the complete rebuilding of Castro Street's streetscape. The sidewalks were widened with an innovative "flex-zone" space that allowed for either parking or sidewalks cafés. New streetlights, trees, kiosks, benches, and planters gave the street a more pedestrian friendly European feel. At the time, critics of the project were concerned that the reconstruction of the street would destroy the funky, ethnically diverse, atmosphere that Mountain View's downtown had gained since its heyday as the city's premier shopping destination in the 1950s. Nearly 20 years later, Castro Street has managed to retain its diversity and is now viewed as one of the most successful downtown revitalizations in the state. This photograph shows the intersection of Castro Street at Villa Street towards the end of its reconstruction. At the right corner of this image stands the old Swall Building, completely modernized and expanded to three stories. (Photograph by Joe Melena; courtesy MVPL.)

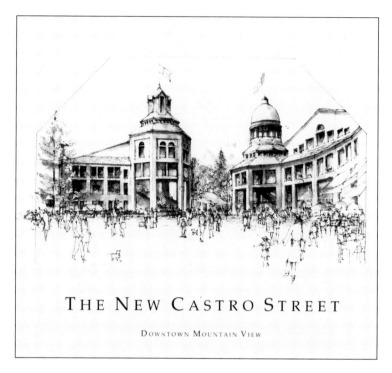

THE NEW CASTRO STREET

DOWNTOWN MOUNTAIN VIEW

Promotional material for the "new" Castro Street featured this watercolor rendering of the project's centerpiece, the new Mountain View Civic Center. A competition was held to determine the design of the civic center's new city hall and center of the performing arts. The winning design was created by William Turnbull Associates and features salmon-colored post-modern buildings facing a large public plaza. (Courtesy MVPL.)

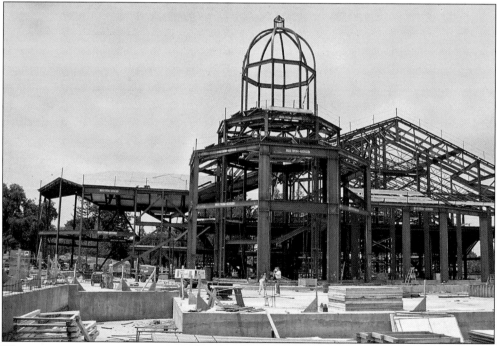

The massive civic center project cost $44.5 million dollars and was completed in 1991. Pictured here is the Mountain View Center of Performing Arts during construction in 1989. The landmark structure features two indoor stages, including a 625-seat main stage and one outdoor stage adjacent to Pioneer Memorial Park. (Photograph by Bob Weaver.)

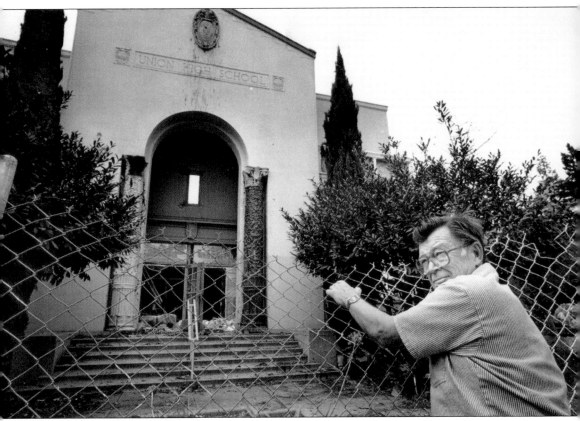

In 1981, the Mountain View community was heartbroken when the high school district decided to close Mountain View Union High School and redistribute its students to the campuses of Los Altos and Awalt High Schools. As part of the decision, Los Altos High adopted Mountain View's blue and gray colors and eagle mascot and Awalt was renamed Mountain View High School. Contrary to a commonly held belief, the old high school was not closed due to seismic safety or maintenance issues. It was chosen for closure due to its small size, high property value, and because its diverse student body could be used to integrate the district's other two schools. For a few years, the campus was used as an informal community center, but when the city was given the option of buying the property, the council only chose to purchase the athletic fields, now home to Eagle Park. The rest of the historic campus was demolished in 1987. Former teacher Hal Partelow grips the chain-length fence surrounding the demolition site in this image. (Photograph by Joe Melena; courtesy MVPL.)

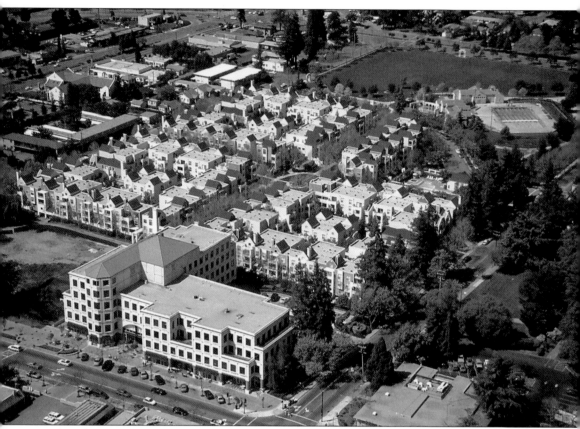

This photograph depicts the old Mountain View High School property after its redevelopment around 1990. Although the demolition of the high school is still seen as a controversial move, the development that replaced the beloved campus helped put the city's downtown redevelopment efforts in the national spotlight and was prominently featured in the September 17, 1989, edition of the *New York Times*. Prometheus Development Company's $150 million project has become a model for a new wave of downtown developments. The project includes a dense mix of apartments, offices, stores, and restaurants oriented along a pedestrian promenade connecting Castro Street with Eagle Park on Shoreline Boulevard. The design used for the park's pool area and gateway arches are a modern interpretation of the schools' architecture. A few artifacts from the old high school, including its flagpole, tile mosaics, and various pieces of the main building's facade, are scattered throughout the site. (Photograph by Bob Weaver.)

Four

THE NORTH BAYSHORE DISTRICT AND MOFFETT FIELD

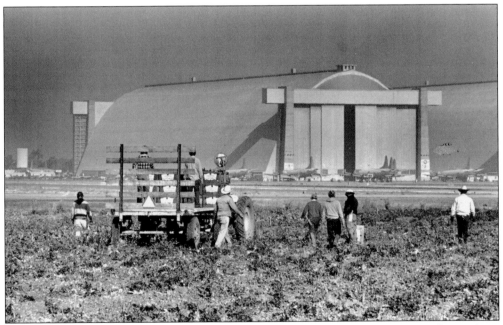

Farm workers tend to the crops near Moffett Field in 1987. Some of the last farms in the northern Santa Clara Valley were located in the North Bayshore District, the area of Mountain View north of the Bayshore Freeway (Highway 101). Plans to transform the area into a new residential neighborhood with a college campus were shelved to build the office parks now occupied by companies like Google and Microsoft. (Photograph by Sam Forencich; courtesy MVPL.)

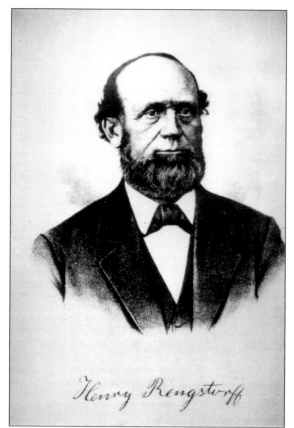

Henry Rengstorff

In 1850, Henry Rengstorff came to California from Germany at the age of 21. Rengstorff arrived too late to profit from the gold rush and instead found riches in the Santa Clara Valley as a farmer. In 1864, he purchased land now occupied by the Shoreline Business Park and established a ship landing nearby. Rengstorff Landing was one of a number of landings where Mountain View's early farmers shipped their crops to San Francisco. (Courtesy MVPL.)

The Rengstorff house was built in 1867 by Henry Rengstorff for his wife, Christine Hassler Rengstorff, and their seven children. The ornate 12-bedroom Victorian mansion was, by far, the grandest home in the Mountain View area when it was built. By the time this photograph was taken in 1976, the once proud structure had fallen into disrepair and was rumored to be haunted. (Photograph by Ken Yimm; courtesy MVHA.)

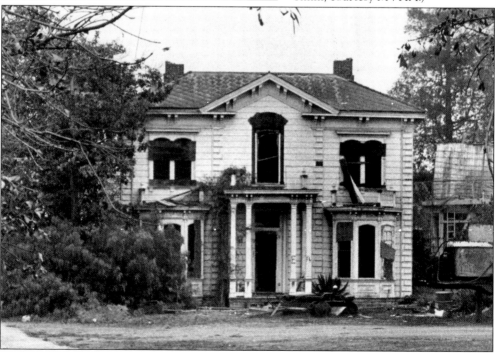

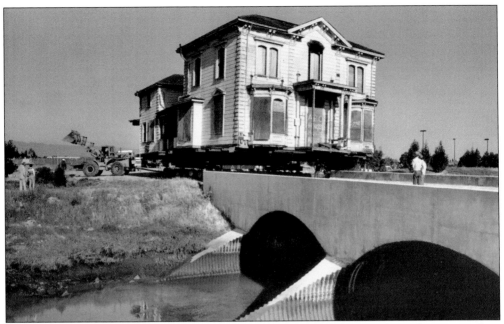

In 1976, the kidnappers in the infamous Chowchilla bus kidnapping planned on using their ransom money to restore the Rengstorff House. Their plans failed after they were apprehended. In 1979, the city purchased the house for $1 and moved it from Stierlin Road (now Shoreline Boulevard) to a temporary location inside Shoreline Park. This photograph displays the home in 1986 during its move across Permanente Creek to its present location. (Photograph by Joe Melena; courtesy MVPL.)

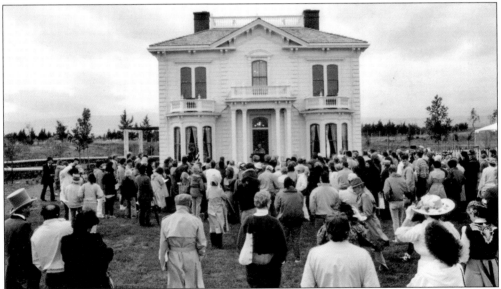

A crowd gathers to celebrate the restoration of the Rengstorff House in 1991. It took $1.2 million and hours of volunteer work to save Mountain View's oldest building from demolition—a fate many thought was certain during its bleakest days when the Hells Angels rode their motorcycles up and down the abandoned house's staircase. Today the Rengstorff House is used as a museum and offices for Shoreline Park administration. (Courtesy MVPL.)

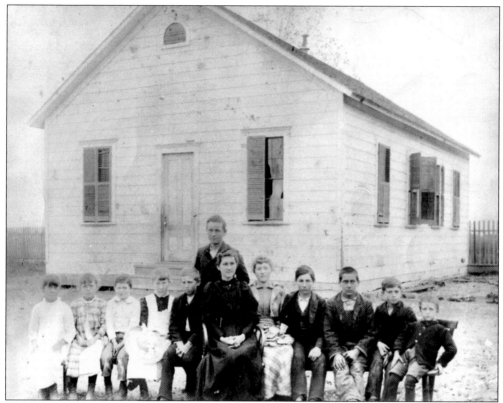

In 1869, Henry Rengstorff led the effort to establish a school for families moving to the area north of Mountain View. In 1871, the first Whisman School was built on land donated by Rengstorff at 1895 Stierlin Road (now Shoreline Boulevard). The school was named after early local stagecoach line operator John W. Whisman. This photograph shows Josephine Bryant and her pupils in front of the school in 1891. (Courtesy MVHA.)

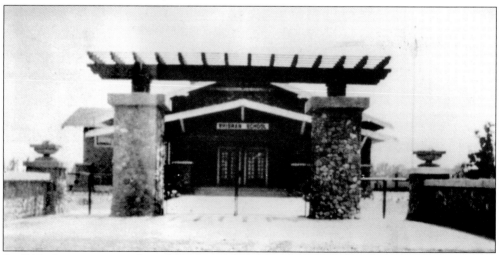

In 1912, the growing number of families and children prompted the construction of this new Craftsman-style Whisman School Building on the same site as the original building. By then, Whisman School's enrollment had increased to 65 pupils. (Courtesy MVHA.)

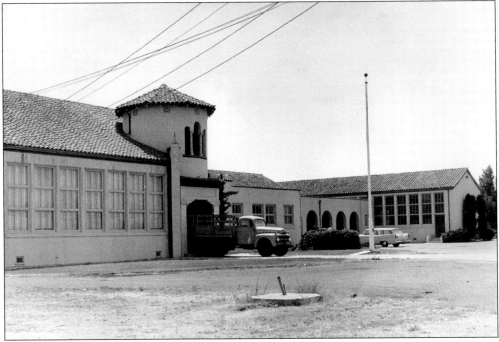

In 1928, the second Whisman School building burned down and it was replaced with this Mission-style edifice with three classrooms, an assembly hall, and kitchen. In 1961, rapid increases in enrollment prompted the district to abandon the site and relocate Whisman School to a new campus at 310 Easy Street. The Easy Street campus still stands, but the school was closed in 2000. (Courtesy MVHA.)

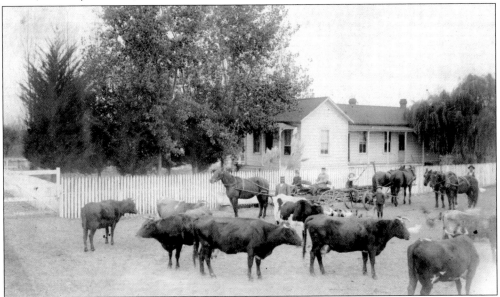

A herd of cattle graze in front of the home of the Reverend Orrin Crittenden and his wife, Virginia Smith Crittenden. The Reverend Crittenden was a Baptist minister who came to Mountain View in 1853. Their 160-acre ranch was one of the first in Mountain View. It is now a part of Moffett Field. (Courtesy MVHA)

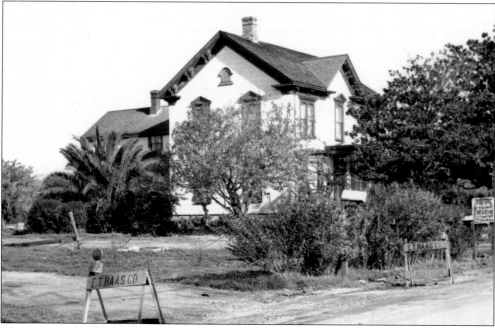

The James A. Huff house was located on the corner of Plymouth Street and Huff Avenue. The Huff family came to Mountain View from Michigan by wagon train in 1863. This photograph shows their home in 1969. Although the house was demolished, the Diericx Drive house of James and Emily Huff's son Frank L. Huff still stands as one of southern Mountain View's most prominent historic homes. (Courtesy MVHA.)

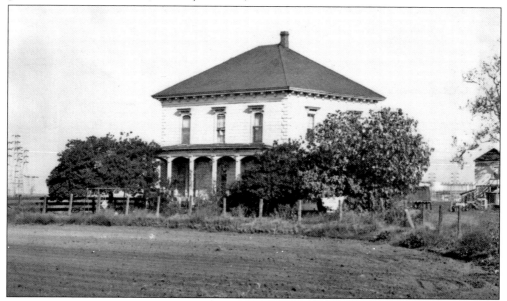

The Stierlin family's ranch, Los Alamos, was located directly south of Henry Rengstorff's property near what is now the intersection of Shoreline Boulevard (formerly Stierlin Road) and La Avenida. Conrad Stierlin was a Swiss immigrant who lived in Mountain View from 1852 to 1904. The Stierlin home was still standing in 1964 when this photograph was taken. The site is now home to a Microsoft campus. (Courtesy MVHA.)

Like Henry Rengstorff, pioneer Charles Guth, known to some as "captain," also established a landing on Mountain View's bayside. The landing featured a wooden and a brick warehouse that collapsed in the 1906 earthquake. Shipping ceased due to competition with the railroad, and Guth's landing later became a popular bathing spot. The Guth home, pictured here, was located on land now occupied by Shoreline Park. (Courtesy MVHA.)

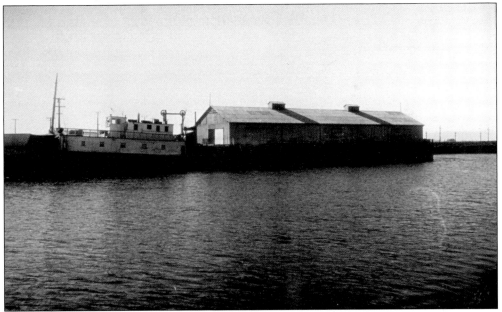

The South Shore Port Company operated Mountain View's last active shipping area from 1923 to 1927. The port was located at the end of Whisman Road on land now part of Moffett Field. In addition to being an active passenger ferry and freight terminal, the port also featured the Kingsport Plunge, a large saltwater pool popular with Mountain View youth during the 1920s. (Courtesy MVHA.)

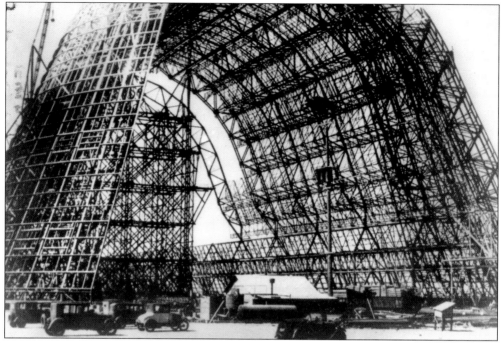

In 1930, Bay Area cities banded together to beat San Diego to become the location of the navy's new lighter-than-air-ship base. Originally the base was to be named Mountain View–Sunnyvale Naval Air Station (NAS), but navy officials became concerned that an airship base with the word "mountain" in its name would make Congress officials jittery. Pictured here is the base's most prominent landmark, the massive Hangar One, under construction in 1932. (Courtesy MVHA.)

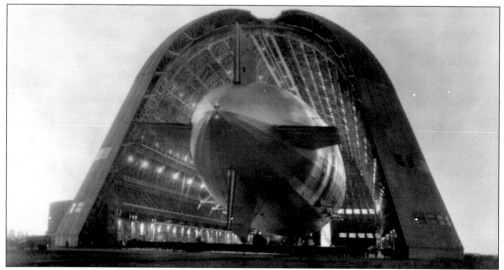

Hangar One was built to house the USS Macon, one of two airships in the navy's ill-fated dirigible program. Just days before the commissioning of NAS Sunnyvale in April 1933, the Macon's sister ship, the USS Akron, crashed into the Atlantic Ocean. Two years later, delays in repairs caused the Macon to crash off the coast of Big Sur. Luckily 80 of the crew's 82 members survived. (Courtesy MVHA.)

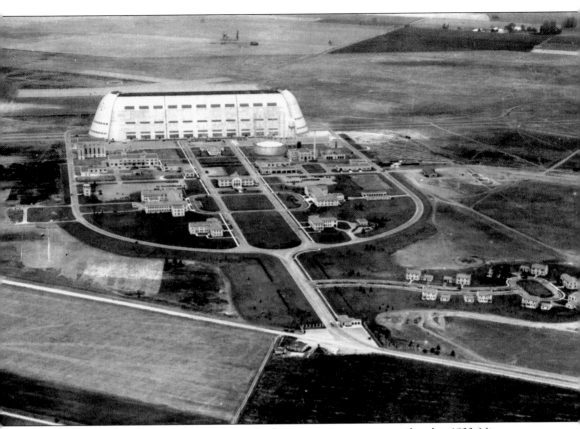

Pictured here is the NAS Sunnyvale shortly after construction was completed in 1933. Nine years later, the base was renamed NAS Moffett Field in honor of Admiral William Moffett, who died in the USS *Akron*'s crash. Moffett Field's boundaries roughly parallel those of Ohlone Indian Lope Inigo's *Rancho Posolmi*, one of the few Mexican-era land grants given to a California Indian. Inigo sold most of his rancho to early settlers or lost it to squatters. Broccoli, cauliflower, and hay fields occupied the area when it was purchased with funds raised from cities throughout the Bay Area and donated to the navy. The loss of the USS *Macon* in 1935 left the navy with no need for the base and it was transferred over to the army. Actor Jimmy Stewart was one of many cadets trained at the airfield during its army years. In 1940, the National Advisory Committee on Aeronautics, the precursor to the National Aeronautics and Space Administration (NASA), established the Ames Research Center at the base. With the onset of World War II, Moffett Field was returned to the navy, which maintained stewardship until 1992 when the base was decommissioned and given to NASA. (Courtesy MVPL.)

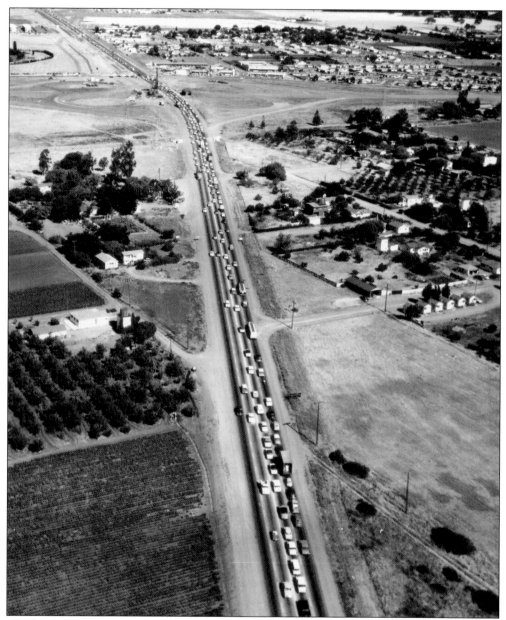

The history of the Bayshore Highway (U.S. 101) stretches back to the rancho-era, when it was known as the Camino Antiguo Vernano or the Old Summer Road. It was also commonly known as the Lower San Francisco Road. Although it was the most direct route between San Francisco and San Jose, winter rains made the roadway impassable and El Camino Real became the route of choice. Mountain View pioneer John W. Whisman established California's first stagecoach line on the Lower San Francisco Road in 1849. In the 1930s, the roadway was upgraded into the Bayshore Highway and once again became a popular alternative to the increasingly clogged El Camino Real. In this 1957 photograph, the Bayshore Highway is in the process of being upgraded into a freeway. The beginnings of a new cloverleaf interchange are starting to emerge at the highway's intersection with Moffett Boulevard near the top of the photograph. The orchards and farms at left of the highway are now a part of Mountain View's Microsoft campus. (Courtesy MVPL.)

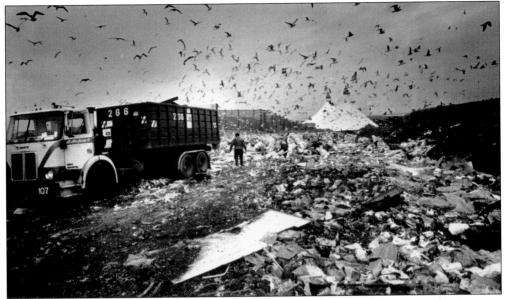

In 1969, the City of San Francisco faced a garbage crisis and needed a new place to dump its refuse. At the same time, Mountain View needed to raise the level of its low-lying bay lands to develop Shoreline Park. The two cities inked a deal where San Francisco paid Mountain View to bury its garbage on the park's site along the San Francisco Bay. (Photograph by Ellen M. Banker; courtesy MVPL.)

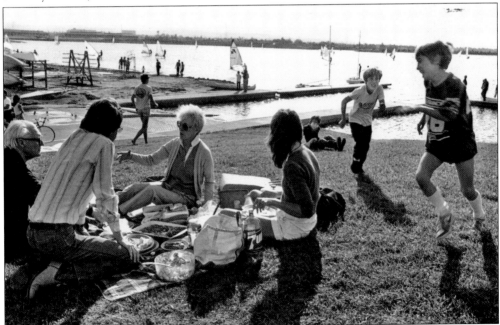

In 1982, after decades of being used as a landfill, the vision of turning Mountain View's bayside into a regional park finally became a reality. The first phase of Shoreline Park opened to the public on July 17, 1982. This 1985 Easter Sunday photograph offers an early view of the area near the manmade 80-acre Shoreline Sailing Lake. (Photograph by Deanne Fitzmaurice; courtesy MVPL.)

In this March 1986 photograph, the famous concert promoter Bill Graham stands on the construction site of his latest venue, Shoreline Amphitheatre. The amphitheatre was built on land formerly occupied by the city landfill. Small fires plagued the amphitheatre during its early years when methane seeping from the rotting trash below its lawn seats would ignite when someone lit a cigarette. (Photograph by Sam Forencich; courtesy MVPL.)

Construction crews prepare to raise the massive fiberglass tent of Shoreline Amphitheatre in 1986. At the time, the $2 million tent was the largest of its kind in the world. Protected from the elements are 6,500 fixed seats beneath its twin peaks. Today the flag-topped white tent is one of Mountain View's most recognizable landmarks. (Photograph by Sam Forencich; courtesy MVPL.)

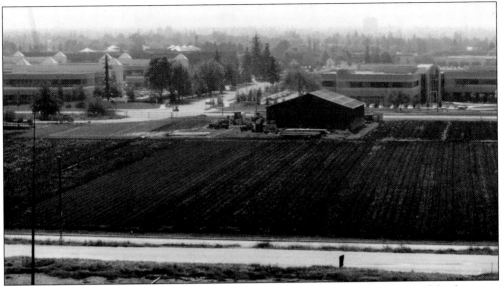

Farmer's Field, a large city-owned swath of land along Charleston Road, was one of the few areas in the North Bayshore District still occupied by farms when this 1992 photograph was taken from Vista Slope in Shoreline Park. The City of Mountain View eventually plans on leasing the remaining 14.4 undeveloped acres of Farmer's Field to a major hotel. (Photograph by Joe Melena; courtesy MVPL.)

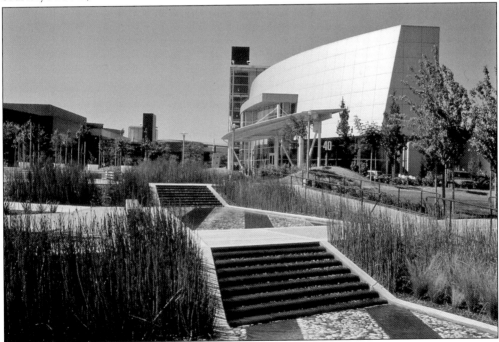

In 1997, SGI (formerly Silicon Graphic Incorporated) opened the doors to its impressive corporate headquarters on Farmer's Field. The SGI campus was built in conjunction with the adjacent seven-acre Charleston Park, seen in the foreground of this photograph. In 2003, SGI vacated the site and Internet search giant Google moved its headquarters into the landmark campus, which is now nicknamed the Googleplex. (Photograph by Robert Weaver.)

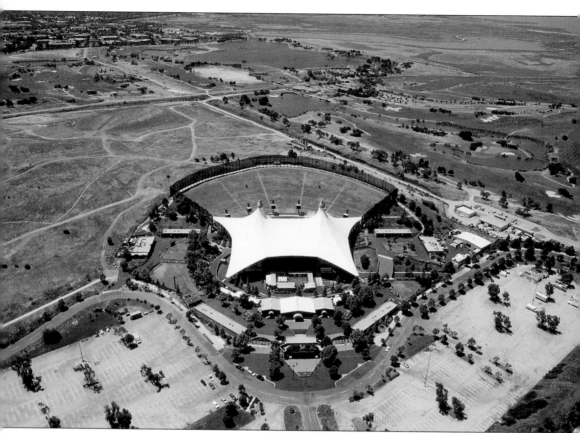

Shoreline Amphitheatre, the Shoreline Golf Links, and Shoreline Park can all be seen in this recent aerial photograph of Mountain View's bayside. Today the Shoreline area is a peaceful refuge for both people and native wildlife. However earlier plans called for a much more intense use of the park's 660 acres. The 1968 plans for Shoreline Park included shopping areas, a hotel, a conference center, a children's zoo, a small amusement park, a marina, and an aerial tram over the sailing lake. Increased environmental awareness in the 1970s led to a greater emphasis on the preservation and restoration of marshlands and undeveloped open space. The egrets and burrowing owls that call Shoreline's marshes and grasslands home almost had some very interesting and exotic neighbors. In the early 1980s, Mountain View seriously considered allowing Marine World Africa, U.S.A. to relocate its elephants, killer whales, and lions from Redwood City to a new amusement park on land now occupied by Shoreline Amphitheatre. (Photograph by Robert Weaver.)

Five

AROUND TOWN

Until the 1950s, the built-up area of Mountain View was mostly confined to the area between Central Expressway and El Camino Real. The post–World War II growth boom rapidly transformed the agricultural areas to the north and south of town into a number of new neighborhoods. The subdivision advertised in this particular photograph replaced orchards near El Monte Avenue and is now a part of the Gemello Neighborhood. (Courtesy MVPL.)

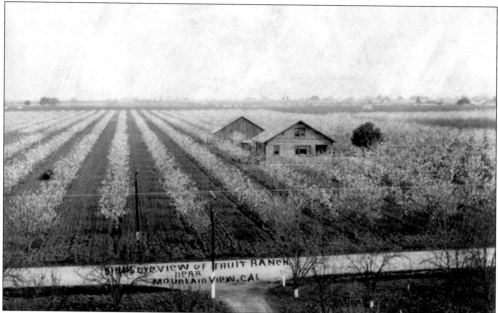

Seemingly endless vistas of blossoming orchards were once common south of El Camino Real. This particular scene shows the Barney Job Ranch on Grant Road. As of publication, Mountain View's last farm, known as the Pumpkin Patch, still occupies 15 acres of the ranch. The farm is one of a handful of agricultural plots that have survived long enough to give 21st-century residents of Mountain View a taste of the city's rural past. (Courtesy MVHA.)

Benjamin T. Bubb's ranch was located near what is today the intersection of Cuesta Drive and Miramonte Avenue. Bubb came to Mountain View from Missouri with his family in 1849 and acquired the ranch in 1868. Benjamin T. Bubb Elementary School and the First Presbyterian Church occupy land once encompassed by the ranch. (Courtesy MVHA.)

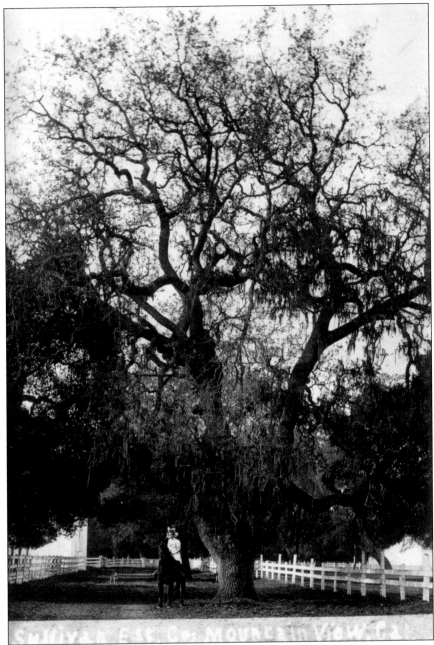

In 1853, John Sullivan purchased a ranch from Mariano Castro's daughter Maria Josefa and her husband, Peter Davidson. The large 400-acre estate was located between Whisman Road and Stevens Creek and extended from El Camino Real all the way to what is now Highway 101. The property was known for its groves of massive oak trees, such as the one featured in this postcard. Sullivan came to California in 1844 in the first wagon train to cross the Sierra Nevada. He was accompanied by two other very prominent early Santa Clara Valley pioneers: Elisha Stephens, whom a misspelled Stevens Creek is named after, and Martin Murphy Junior, who purchased the eastern half of the Castro rancho and founded the city of Sunnyvale on his land. (Courtesy MVHA.)

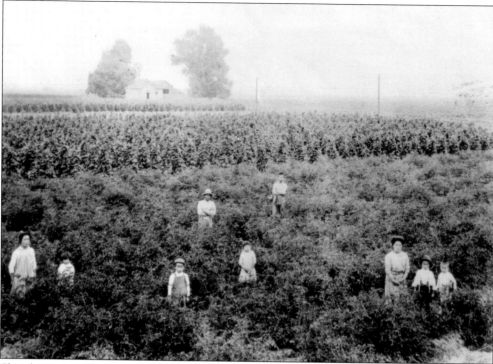

Shuichi Hori and his wife, Asa Kanegai, came to Mountain View with their two children in 1913 after fleeing San Francisco's Chinatown during the Tong Wars. The Horis were one of about 100 Japanese families who settled in Mountain View during the early 1900s. The family leased the 35-acre bean and tomato ranch, pictured here, from William P. Wright. The IFES Portuguese Hall now occupies the site of the ranch. (Courtesy MVHA.)

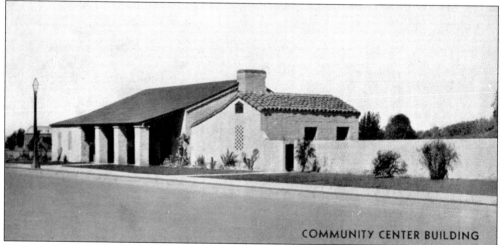

COMMUNITY CENTER BUILDING

The Adobe Building on Moffett Boulevard, a nationally registered historic landmark, was constructed in 1934 under the Works Progress Administration. Adobe bricks manufactured on-site were used in the building's walls. The Adobe was home to a soldier's lounge during World War II, high school dances when it was known as the Eagles Shack, and numerous classes, meetings, and celebrations. Strong community support saved the building from demolition and led to its restoration in 2001. (Courtesy MVHA.)

The Ferry-Morse Seed Company opened its western headquarters on Evelyn Avenue and Whisman Road in 1951. When the plant opened, Ferry-Morse was one of just a handful of major industrial operations in Mountain View, and its arrival was welcomed with great excitement. (Courtesy MVPL.)

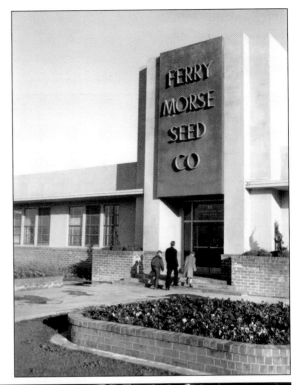

This interior shot of the Ferry-Morse Plant shows workers along the assembly line for boxes of the company's Golden Gate Park Seed Mix. Ferry-Morse operated its Mountain View location until 1985. The plant was demolished and has since been replaced with the Mountain View Corporate Center office park. (Courtesy MVPL.)

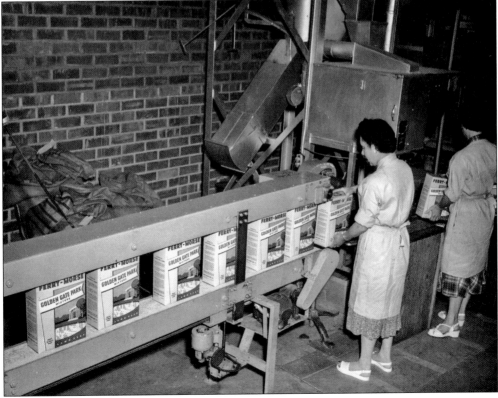

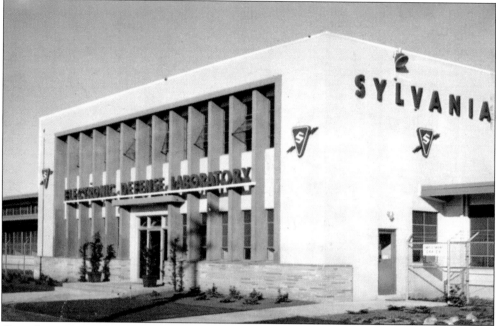

One of companies that helped position Mountain View as an early center for the defense and high-tech industries was the Sylvania Corporation when it opened a campus north of the railroad tracks at Whisman Road in 1953. The defense company was purchased by the GTE Corporation in 1959 and by the early 1960s had grown to become Mountain View's largest employer.

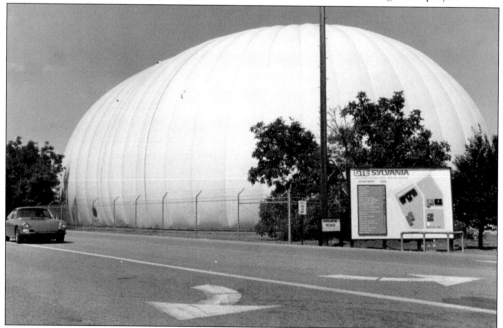

The GTE Sylvania "bubble" was one of Mountain View's most unusual landmarks. The company built the nylon-inflated structure at the corner of Central Expressway and Ferguson Drive in 1963 as an antenna-testing facility. In the mid-1990s, the Whisman Station neighborhood replaced most of the 55-acre GTE Sylvania campus, including the bubble. (Courtesy MVPL.)

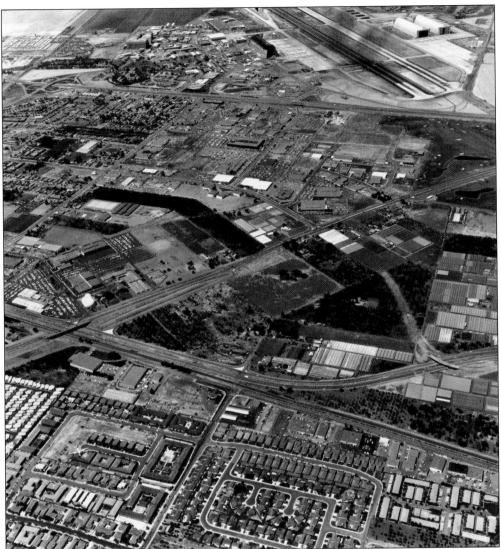

Agricultural lands and newly built industrial parks stand side by side in this photograph of the Whisman District around 1970. The Whisman District is a triangular-shaped portion of north Mountain View separated from the rest of the city by freeways. The old Mountain View–Alviso Road, now known as Highway 237, runs diagonally across the middle of the photograph. The dark band at center is the Francia and Kalcic Orchards. Today the Francia Apricot Orchard on Whisman Road is the last productive orchard in the entire city. Above the orchards stand Mountain View's earliest high-tech industrial park areas where pioneering Silicon Valley companies such as Fairchild Semiconductor were once located. GTE-Sylvania and its bubble building are located near the bottom left of the photograph. This area of Mountain View experienced widespread redevelopment in the 1990s. A new light-rail trolley line links the Whisman District to Downtown Mountain View and many of the properties adjacent to the tracks have been redeveloped with housing and modern office parks. (Courtesy MVPL.)

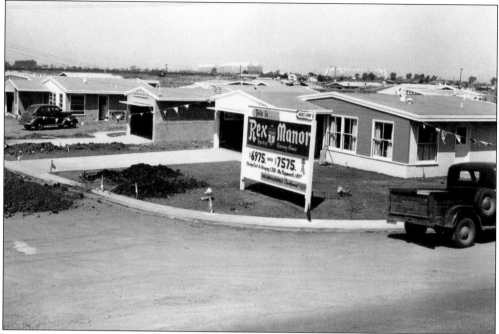

In 1950, contractor William Blackfield completed the first homes in Rex Manor, Mountain View's first major post–World War II residential subdivision. The 394 homes north of Alma Street (now Central Expressway) along Farley and Burgoyne Streets originally sold from between $6,895 to $7,775. The once affordable, two- and three-bedroom dwellings now sell for well over $600,000. (Courtesy MVHA.)

This c. 1960 photograph shows Rengstorff Avenue at Old Middlefield Road. The author's grandparents Anthony and Elizabeth Perry operated the Middlefield Food Center at right. The current tenant, La Costeña Market, is locally famous for its popular burrito bar. In 1997, La Costeña's owner Ramon Luna put Mountain View in the Guinness Book of World Records when he organized the creation of the world's largest (3,858-foot-long) burrito in Rengstorff Park. (Courtesy MVPL.)

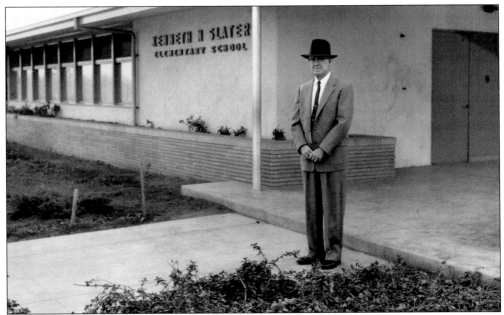

As residential construction boomed throughout Mountain View during the postwar era, Mountain View's school districts raced to build enough classrooms to house their growing student populations. In this 1956 photograph, Mountain View School District superintendent Kenneth N. Slater stands in front of the district's new elementary school campus on Gladys Avenue. The school was named in his honor for over 40 years of service to the community. (Courtesy MVHA.)

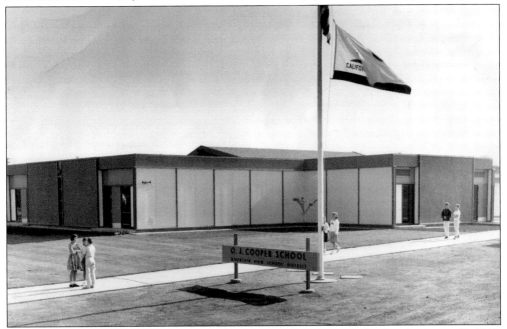

The caption underneath a similar photograph of the new O. J. Cooper School in the August 31, 1963, edition of the *Peninsula Times Tribune* reads, "It's a school," as if to assure people that the modern building they were viewing was not a warehouse of some sort. The 12-room elementary school on Eunice Avenue was designed to facilitate team-teaching. It closed in 1976. (Courtesy MVPL.)

The intersection of Miramonte Avenue and Castro Street is still quite rural in this 1961 photograph. The children crossing Miramonte Avenue were likely on their way to Graham Middle School, pictured at far right, on Castro Street. The uniformed students walking along Miramonte Avenue at left are from St. Joseph's Catholic School, which opened its campus at 1120 Miramonte Avenue in 1954. (Courtesy MVPL.)

In 1959, after nearly a century at its original location on Castro Street, the First Presbyterian Church relocated to a new site on the corner of Miramonte Avenue and Cuesta Drive. As a gesture to the church's past, the historic bell donated by Edward Dale for the original 1859 sanctuary was hung from a memorial monument located on the side of the church. (Courtesy MVHA.)

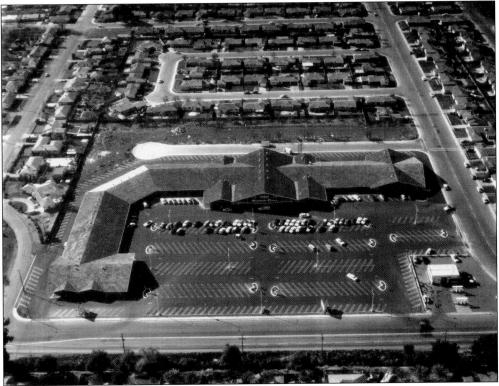

Blossom Valley Plaza opened in 1957 on the southwest corner of Miramonte Avenue and Cuesta Drive. The new shopping center instantly became the hub of commerce for the rapidly growing residential area of Mountain View south of El Camino Real. (Courtesy MVPL.)

As Mountain View and its neighboring cities grew, the need for a new regional hospital emerged. In 1956, voters approved the formation of a new hospital district and the following year approved a $7.3 million bond to finance the construction of El Camino Hospital on a 20-acre Grant Road orchard. The hospital's main building, seen here shortly after it was completed in 1962, will soon be replaced due to seismic safety concerns. (Courtesy MVPL.)

From 1953 to 1987, the northwest corner of Grant Road and Cuesta Drive was marked by this City of Mountain View water tower. The sign on the corner reads, "Progress Today for a Brighter Tomorrow" and heralds the upcoming construction of Mountain View Fire Station No. 2. Concerns that an earthquake could topple the tank and damage the fire station below led to the water tower's removal. (Courtesy MVPL.)

Motorists on Grant Road waiting to turn right on to Cuesta Drive may notice an odd plaque marking the site of the Witness Tree. The old, wild cherry tree was used as a boundary marker in an 1865 government survey and by settlers to locate their land. This 1957 photograph shows members of the Mountain View Pioneer and Historical Association during the dedication of their historic marker for the tree. The landmark tree fell down in a 1970 storm. (Courtesy MVHA.)

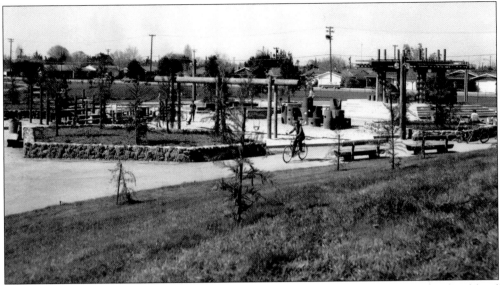

Cuesta Park was financed from a 1966 bond and was built on 26 acres of former orchard land south of Cuesta Drive. In this 1970 photograph, the newly landscaped park's coast redwoods are only saplings, and the children's playground bares little resemblance to the shady refuge it has grown to become today. (Courtesy MVPL.)

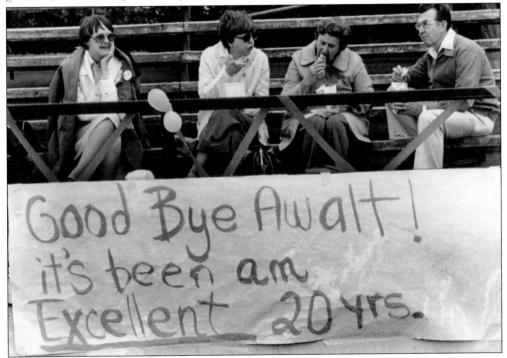

In 1960, Awalt High School opened on the southernmost tip of Mountain View on Truman Avenue. The school was named after Chester F. Awalt, a high-school district trustee who witnessed the construction of all three of the district's campuses during his tenure. In 1981, parents and students said goodbye to their school's name after the district decided to transfer the "Mountain View" name from the old Castro Street campus to Awalt. (Photograph by Ken Yimm; courtesy MVPL.)

One common thread uniting many of the neighborhoods seen in this chapter is a connection to the Stevens Creek Trail. The vision for it first emerged in a 1959 Santa Clara County plan. The trail was to be developed in conjunction with the Stevens Creek Freeway (Highway 85) and stretch from the San Francisco Bay through the cities of Mountain View, Los Altos, Sunnyvale, and Cupertino all the way to Stevens Creek Reservoir in the Santa Cruz Mountains. For nearly three decades, the City of Mountain View has taken the lead in making this vision a reality. The first leg of Mountain View's portion of the trail was built in Shoreline Park in 1991. Today the trail travels through the North Bayshore District, the Whisman District, and Old Mountain View. It will soon be extended south of El Camino Real and connect the rest of the city with the campus of Mountain View High School. (Courtesy Robert Weaver.)

Six

COMING TOGETHER

Look closely at this photograph, and the diversity that has defined the Mountain View community for generations can be seen. The year is 1950 and a large cross-section of the community has gathered in the old Mountain View High School auditorium to watch a performance during the city's Harvest Festival. Mountain View's residents were quite proud of their town's multicultural identity—enough so to make it the theme of the city's mid-century Harvest Festivals. (Courtesy MVHA.)

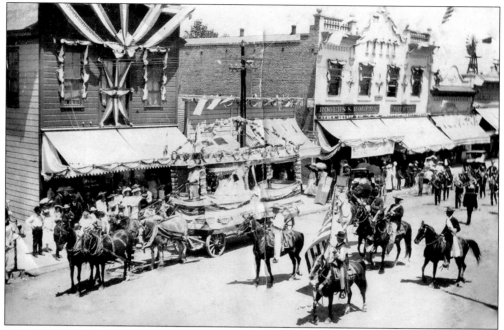

In 1895, Mountain View residents celebrated the Fourth of July with a parade down Castro Street. The 100 block of the street was decked out in patriotic flags and banners. Notable structures in this photograph include the Rogers and Rogers Building, the Mountain View Bank Building, and at far right the Weilheimer General Store Building. (Courtesy MVHA.)

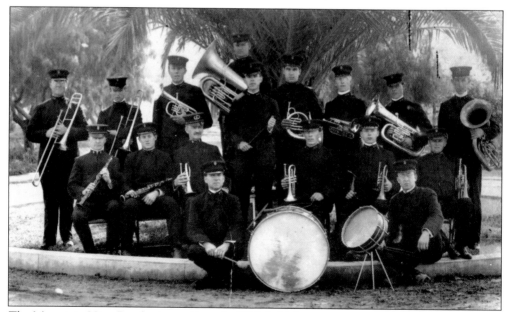

The Mountain View Band, pictured here in 1914, held frequent concerts on Castro Street. The band members are, from left to right, (first row) B. A. Scott and Olin Tait; (seated in the second row) Charles Vincent, Henry Minton, professor D. W. Lindsay, S. A. Wright, Charles Moore, and ? Smith; and (third row) ? Fredericks, ? Jones, George Jagels, L. H. Lukens, Ernest Chapman, Floyd Brackett, William Moore, unidentified, and Lawrence P. Bailey. (Courtesy MVHA.)

Cycling was a popular activity in Mountain View at the turn of the century. The Mountain View Cyclers Club, organized in 1895, included among its membership many leading local men who now have streets or buildings named after them. Pictured in this 1897 membership photograph, from left to right, are (first row, or bottom) Steve Clark, Houkan Trulsen, Adolph Ehrhorn, and Frank Grant; (second row) Bill Howard, Vince Henderson, V. C. Gates, Victor Distel, and George Sparks; (third row) Henry Weilheimer, Walter Clark, and Tom Rogers; (fourth row) Ed King, Charles Vincent, Jim Kennedy (or Julius Weilheimer), John Cronin, and John Francis; (fifth row) Fred Francis, John Bailey, Bill Garliepp, and Fred Cutter; (sixth row) Dan Malone, G. K. Estes, George Taylor, Mr. King, and Ed Warfel; (seventh row) Dr. Emerson, Dick McDonald, Phil Clark, and Andrew Castro; (eighth row) Louis Girand, J. H. Mockbee, Jack Schaub, Samuel Weilheimer, and Bill Neuroth; and (ninth) Jacob S. Mockbee, Frank Abbott, "Slug" Fackrell, and Frank Francis. (Courtesy MVHA.)

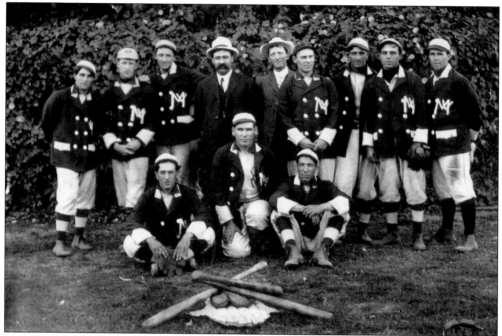

Mountain View fielded its own baseball team during the early years of the 20th century. The 1906 team, pictured here from left to right, are (first row) Joseph Rose, Jack Lyons, and Shorty Pereira; (second row) and John Carreira, unidentified, Emmet Graham, Emil Darriman (manager), Mr. Roche (number one rooter), Frank Farry, Toney Vargas, Joseph Carreira, and Frank Foley. (Courtesy MVHA.)

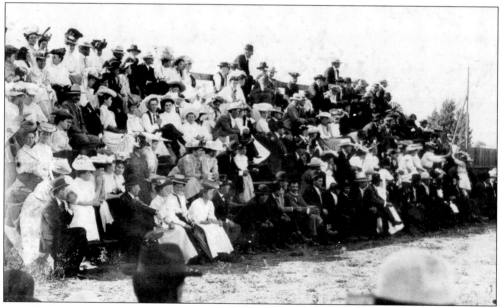

In 1907, the *Mountain View Leader* described the Mountain View Baseball Team as "practically invincible." Large crowds such as the one pictured here on August 19, 1906, filled the bleachers of a field located behind Taylor's Hotel in the Old Town to root on their locally famous team. (Courtesy MVHA.)

After the *Pacific Press* came to Mountain View in 1904, its Seventh-day Adventist workers established their own schools and community organizations on the west side of town. One such organization was the Pacific Press Orchestra, pictured here in 1917. The piano player is Esther Miramontes and the trumpet player is Arthur Wright. (Courtesy MVHA.)

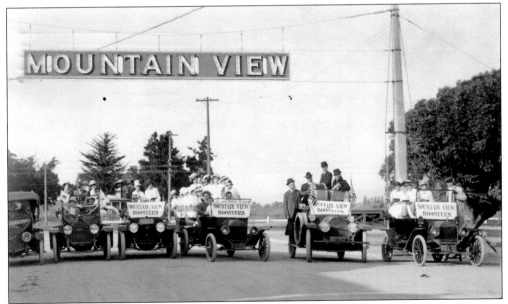

Members of the Mountain View Boosters Club pose underneath the newly installed electric "Mountain View" sign that was placed over Castro Street near the railroad crossing in 1915. The landmark sign was removed sometime in the 1930s. (Courtesy MVHA.)

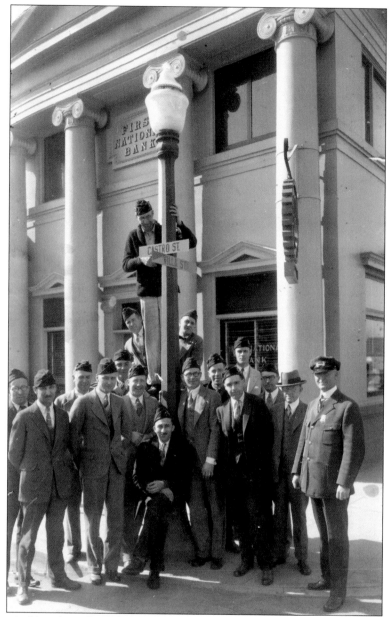

The Mountain View branch of American Legion was formed in 1921. An early group activity for the American Legion was the installation of street signs. In this 1934 photograph, members stand on the corner of Villa and Castro Streets in front of the First National Bank Building at 206 Castro Street. Few photographs exist that show the facade of the First National Bank Building in its original c. 1912 condition. Although the building still stands, its columns and pediment were removed in the 1950s. For decades, the structure has served as the local lodge of the International Order of Odd Fellows (IOOF). Clarence Lawson poses from behind the left side of the lamppost, and Herman Stalford holds onto the street sign. The men in front of the lamppost are, from left to right, James Frank Glann, Paul Marcetti, James T. Wylie, James L. Jones, unidentified, Maj. James M. Graham, Isadore Jacoby (seated), Robert S. Knight, Arthur Hurlock, unidentified, unidentified, ? Cochrane, and ? Watkins. (Courtesy MVPL.)

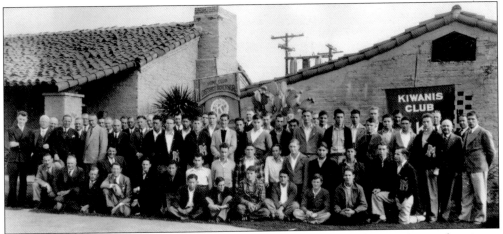

Since 1926, members of the Mountain View Kiwanis Club have been devoting hours of service to the betterment of the community. Members of the club pose with Mountain View High School athletes in front of the Adobe Building in this 1937 photograph. (Courtesy Trudi Tuban.)

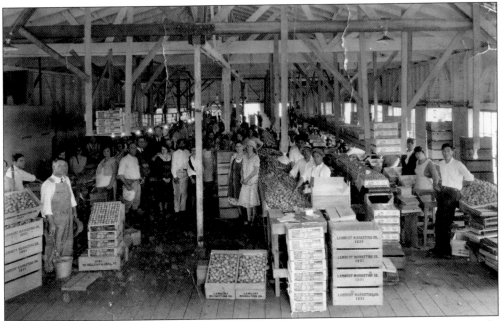

The diverse workforce of the Mountain View Packing Shed poses for this 1931 photograph. Mountain View's canneries and fruit-packing sheds were often the first place where people from the city's various immigrant groups interacted with each other. Workers at the packing shed packed over 80 railroad cars of apricots during the 1931 harvest season. (Courtesy MVHA.)

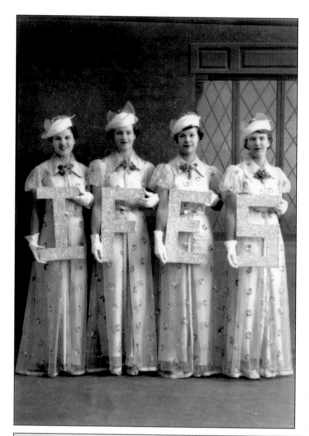

Mountain View is one of the only Californian town of its size to boast two Portuguese halls. Both the Irmandade da Festa do Espírito Santo (IFES) and the Sociedade da Festa Velha (SFV) trace their origins to a Holy Ghost *festa* (festival) celebration held on the Costa dairy farm on Charleston Road in 1926. The IFES hall on Stierlin Road was completed in 1931. Pictured here are four ladies proudly representing IFES in 1937. (Courtesy IFES Society.)

On the sixth Sunday after Easter, members of the IFES parade down Castro Street as a part of their annual Holy Ghost *festa*. The Holy Ghost *festa* is a tradition common to the Azores islands, the homeland of most Portuguese immigrants in California. In addition to the parade, other traditions include the crowning of a queen, a communal feast of *sopas* (soup), and a dance at the Portuguese hall. (Courtesy IFES Society.)

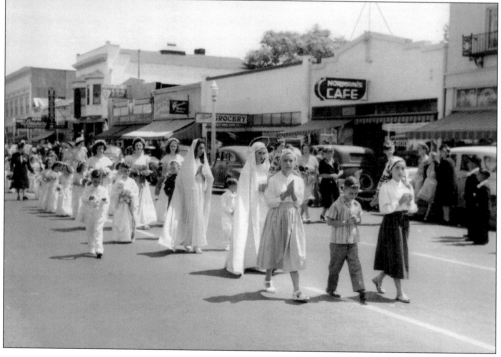

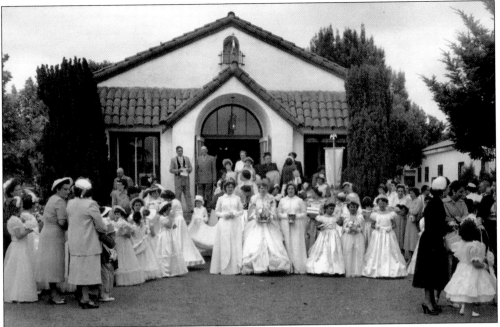

In 1929, the Sociedade de Festa Velha split off from the IFES society and established its own hall on Villa Street in 1935. This 1953 photograph shows SFV members in front of their chapel prior to their Holy Ghost parade. The two men near the door are John Rezendes (left) and John F. Costa (right), the founder of the first Mountain View *festa*. The little queen flanked by two maids at right is Madeline Vierra Borges. (Courtesy Madeline Vierra Borges.)

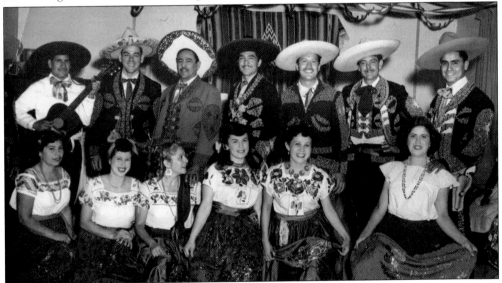

Mexican American residents pose in traditional "charro" outfits in this *c.* 1950 photograph. The author's grandparents, Simon and Emma Sias, are pictured at far right. Mountain View's Mexican population began to grow during the Great Depression with many families settling near Washington Street in "*La Charca de la Rana,*" or "The Frog Pond"—a nickname bestowed upon the neighborhood by its Spanish immigrant population in the 1920s due to its muddy streets. (Courtesy Simon and Emma Sias.)

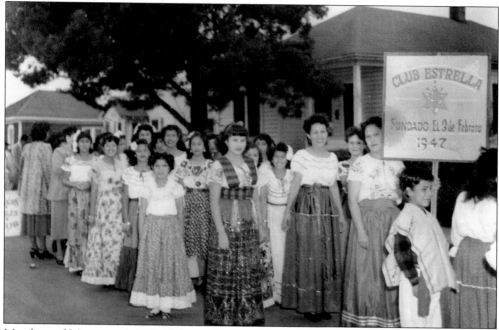

Members of Mountain View's Club Estella assemble on Washington Street in preparation for a parade down Castro Street around 1950. The sign in this photograph is misdated, because Mexican American women living along Washington and Jackson Streets officially founded Club Estrella in February 1948. Nearly 60 years later, the club is still thriving with membership spread throughout the Santa Clara Valley. (Courtesy Simon and Emma Sias.)

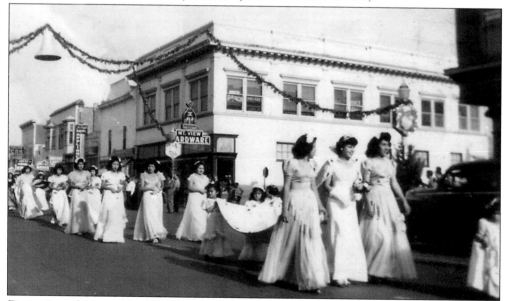

During its early years, Club Estrella organized processions from Washington Street to St. Joseph's Catholic Church in honor of the feast day of the Virgin of Guadalupe. Pictured here is the procession as it passes the Mockbee Building on Castro at Villa Street. Interest in the processions waned in the early 1950s, but the tradition has been resumed by more recent generations of Latino immigrants. (Courtesy Simon and Emma Sias.)

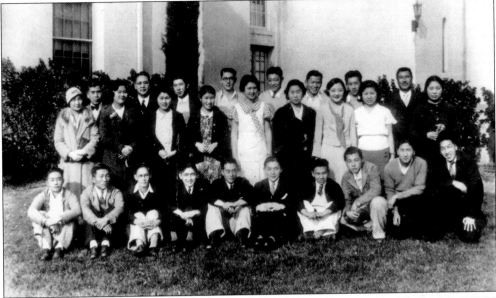

Members of the Nisei generation of Mountain View's Japanese American community were involved in the formation of the Young Buddhist Association. The group is pictured here in front of Mountain View High School on Castro Street in 1928. The Young Buddhist Association was active prior to the internment of the city's Japanese and Japanese American residents in 1942. The group was resurrected in the 1960s and is still active today. (Courtesy MVPL.)

Since 1957, the center of Japanese American and Buddhist culture in Mountain View has been the Mountain View Buddhist Temple on Stierlin Road. Rev. L. Sasaki and a group of girls wearing kimonos pose in this publicity photograph for the 1981 Obon Festival. The Obon is a midsummer celebration of lives lost over the past year that features food, games, and the traditional Bon Odori dance. The popular event was first held in 1952. (Courtesy MVPL.)

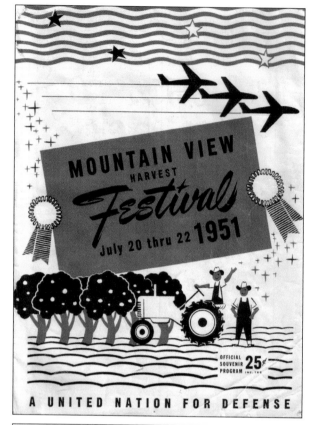

In July 1949, 1950, and 1951, Mountain View celebrated a Harvest Festival. The 1951 festival was used as an opportunity to promote Mountain View as a diverse and welcoming community in-step with the spirit of the United Nations. The souvenir program described the city as a "community which is demonstrating that living together in harmony so essential to the successful outcome of any endeavor for the United Nations." (Courtesy MVHA.)

One of the biggest events during the harvest festivals was a parade down Castro Street. The 1950 parade had 4,000 participants and over 20,000 spectators. Ethnic, cultural, and community groups were invited to compete in the float competition. Pictured here is the Mountain View's Filipino community float traveling down the 200 block of Castro Street past the building currently home to Global Beads. (Courtesy MVHA.)

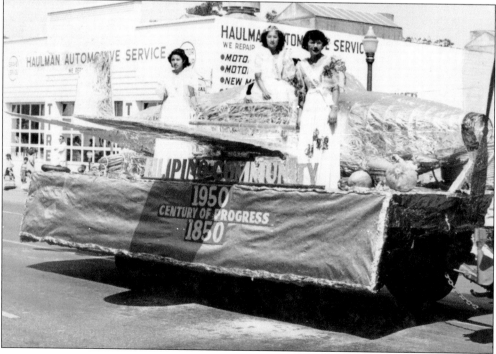

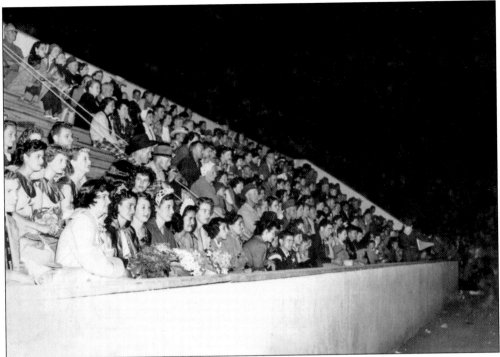

The football field bleachers at Mountain View High School were filled with spectators who came to watch the 1950 Harvest Festival Pageant, "A Quest for Golden Glory." The elaborate spectacle included 1,000 participants who reenacted Mountain View's history and showcased the cultural traditions of the city's Mexican, Spanish, Filipino, and Japanese communities. (Courtesy MVHA.)

Mountain View's various ethnic and cultural groups each put forward their own candidate to be queen of the Harvest Festival. The Mexican "colony's" candidate, Alice Lara, was photographed picking cherries in a Mountain View orchard for this promotional photograph published in the July 6, 1950 *Mountain View Daily Register*. The Spanish community's candidate, Mary Blasquez (pictured on page 14), won the 1950 crown. (Courtesy MVHA.)

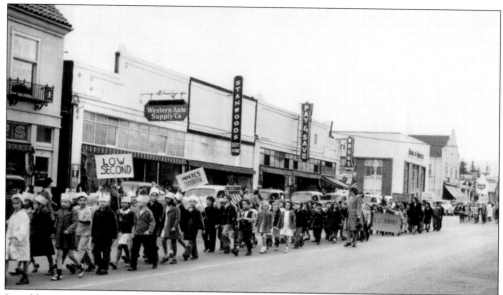

In addition to serving as a celebratory parade route, Castro Street has also been the site of marches for various political causes. In the late 1940s, children from the second-grade classes of Dana Street School marched through downtown holding signs urging residents to "Vote YES Tomorrow" and "Vote Si Mañana" for a bond to fund the construction of the Escuela Avenue School (now Castro School). (Courtesy MVHA.)

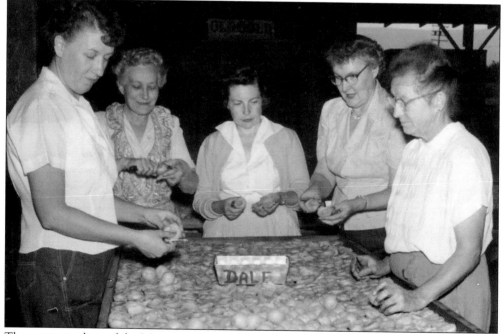

These are members of the Mountain View Business and Professional Women Association at an "apricot cutting party" at the Dale family ranch. Members donated their earnings from the apricots to present a plaque to their association's national headquarters. The women pictured here, from left to right, are Mrs. J. H. Greenwod, Mary Harris, Mrs. E. J. Rossi, Mrs. Milton D. Sayre, and Eleanor Dale. (Courtesy MVHA.)

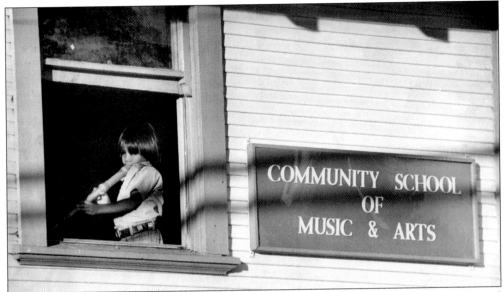

A young student of the Community School of Music and Arts plays the recorder from the second floor of the school's original location at 1560 California Street. The nonprofit school was founded in 1968 by volunteers to give local youth an enhanced arts education. In 2004, the school left its longtime location at Huff School and celebrated the grand opening of the award-winning Finn Center campus on San Antonio Circle. (Courtesy MVPL.)

Seventy-five local school children put the finishing touches on their "American Primitive"–style mural depicting early Mountain View on the corner of California and Castro Streets. The mural was created as a part of the City of Mountain View's 85th-anniversary celebration under the guidance of the Community School of Music and Arts. Since 2000, the mural has been hidden behind the Clocktower Building at 800 California Street. (Courtesy MVHA.)

The crosstown rivalry between the Mountain View High Eagles and the Awalt High Spartans was put aside in this c. 1975 photograph of both schools' cheerleading squads. Football games on Mountain View High's Wendell Grubb Athletic Field (now Eagle Park) were a big community event. Although the games between Awalt and Mountain View were spirited, nothing compared to a gridiron battle between the Mountain View Eagles and their archrival, the Los Altos Knights. (Courtesy Bob Lee.)

A large crowd lines Castro Street in the early evening to witness the first Mountain View Chinese New Year Parade in 1986. The annual celebration grew to become the largest Chine New Year parade between San Francisco and Los Angeles, attracting around 20,000 people to downtown to watch cultural groups, lion dancers, and a 125-foot lighted dragon march down Castro Street. The event was last held in 1998. (Photograph by Sam Forencich; courtesy MVPL.)

Despite pouring rain, a large crowd huddles underneath umbrellas to celebrate the dedication of Creekside Park on Easy Street in 1998. Its location on the banks of Stevens Creek allows for a direct connection with the Stevens Creek Trail via a new bridge over the creek. With little open land left, the city has found creative ways to carve out new open-space areas like Creekside Park and the Stevens Creek Trail. (Photograph by Robert Weaver.)

The award-winning Mountain View High School Spartan Marching Band makes its way down Castro Street in the city's annual Spring Parade. The proud tradition of fielding an impressive marching band was passed on to the new Mountain View High after the old Mountain View High closed in 1981. The band is perhaps a good metaphor for Mountain View—places have come and gone and traditions have changed, but the unique spirit of this community continues to march on. (Photograph by Robert Weaver.)

Festivalgoers traverse a newly rebuilt Castro Street in this *c.* 1990 photograph of the annual Mountain View Art and Wine Festival. First held in 1971, this annual chamber of commerce–sponsored event is one of the oldest and largest celebrations of its kind in California. In recent years, the two-day festival has drawn nearly 200,000 people to Castro Street for music, food, people watching, and, of course, art and wine. (Courtesy MVPL.)

Dancers from the Oriki Theatre bring a mix of the culture and music of Africa to Pioneer Park during a late 1990s Art and Wine Festival. The nonprofit Mountain View–based Oriki Theatre was established in 1992. Its mission is to help Bay Area communities come together and experience the real culture of Africa. (Photograph by Robert Weaver.)